DATE DUE

GAYLORD #3522PI Printed in USA

Forgotten Bookmarks

MICHAEL POPEK

Forgotten Bookmarks

A Bookseller's Collection of Odd Things Lost Between the Pages

A PERIGEE BOOK

A PERIGEE BOOK
Published by the Penguin Group
Penguin Group (USA) Inc.
375 Hudson Street, New York, New York 10014, USA
Penguin Group (Canada), 90 Eglinton Avenue East, Suite 700, Toronto, Ontario M4P 2Y3, Canada
(a division of Pearson Penguin Canada Inc.)
Penguin Books Ltd., 80 Strand, London WC2R 0RL, England
Penguin Group Ireland, 25 St. Stephen's Green, Dublin 2, Ireland (a division of Penguin Books Ltd.)
Penguin Group (Australia), 250 Camberwell Road, Camberwell, Victoria 3124, Australia
(a division of Pearson Australia Group Pty. Ltd.)
Penguin Books India Pvt. Ltd., 11 Community Centre, Panchsheel Park, New Delhi—110 017, India
Penguin Group (NZ), 67 Apollo Drive, Rosedale, Auckland 0632, New Zealand
(a division of Pearson New Zealand Ltd.)
Penguin Books (South Africa) (Pty.) Ltd., 24 Sturdee Avenue, Rosebank, Johannesburg 2196, South Africa
Penguin Books Ltd., Registered Offices: 80 Strand, London WC2R 0RL, England

While the author has made every effort to provide accurate telephone numbers and Internet addresses at the time of publication, neither the publisher nor the author assumes any responsibility for errors or for changes that occur after publication. Further, the publisher does not have any control over and does not assume any responsibility for author or third-party websites or their content.

First edition: November 2011

Library of Congress Cataloging-in-Publication Data

Popek, Michael.
 Forgotten bookmarks : a bookseller's collection of odd things lost between the pages / Michael Popek.—1st ed.
 p. cm.
 ISBN 978-0-399-53701-1
 1. Bookmarks—Miscellanea. 2. Lost articles—Miscellanea. 3. Popek, Michael—Blogs. 4. Antiquarian booksellers—United States—Blogs. I. Title.
 Z996.2.P66 2011
 790.1'32—dc23 2011022731

PRINTED IN THE UNITED STATES OF AMERICA
10 9 8 7 6 5 4 3 2 1

Most Perigee books are available at special quantity discounts for bulk purchases for sales promotions, premiums, fund-raising, or educational use. Special books, or book excerpts, can also be created to fit specific needs. For details, write: Special Markets, Penguin Group (USA) Inc., 375 Hudson Street, New York, New York 10014.

Contents

Introduction

My career as a bookseller began when I was about eight years old. This was the late 1980s, and being a mail-order bookseller like my parents meant you had to scan the weekly edition of *The AB Bookman* for dealers looking for books you had in stock. You would find potential matches, mail out your stock list, and hope for an order to arrive a few weeks later. I remember helping stuff the envelopes that my father would send out, fetching books off shelves, looking up titles in our makeshift card catalog. Kid jobs. Even then, I knew I had entered a peculiar and wonderful world, a world where someone in the universe wanted a fifty-year-old *World Almanac* with no front cover.

By the time I had made my way back to the family business, after college and moving across the country and other required rites of passage, things had changed in the bookselling world, and in our business. There were computers and databases, shipping counters, and a real cash register. We had finally opened up a proper brick-and-mortar shop, and I found myself proclaimed its manager.

My most important task as manager was buying and sorting books. This particular task had quite a learning curve, but I was happy to dive into the mountain of unsorted books to see what I could find. What I found is that I loved the fact that I could come across nearly anything: a moldy copy of *Ulysses*, a Victorian-era scrapbook filled with trade cards, a first edition of Steinbeck. This treasure hunt still remains my favorite part of bookselling and led directly to my fascination with forgotten bookmarks.

I began finding treasures within the treasures, little bits of random

ephemera left inside books, often untouched for decades. One of the first interesting finds I can recall was a collection of black-and-white photographs stuck inside a 1930s textbook of English literature. The photos were all of a group of college friends, taken at various places on campus—typical arms-on-shoulders poses beside the sign at the entrance of the school, humorous candids of friends walking to class, some landscape shots of the sprawling campus with the hills in the distance. At that moment, I wanted to know the story of these people's lives. What school did they attend? Did they keep in touch after graduation? Did Veronica eventually marry Joseph?

Of course, I would never have these answers; I was just left with a lingering wonder, a sense of misplaced nostalgia, and a touch of the voyeuristic thrill that comes from peeping into someone else's life. In that instant, I became a collector—an odd collector of items normally discarded by booksellers, and whose original owners weren't looking for them. I assumed that I was the only one with this particular hobby, but I soon discovered that I was wrong.

One day, I came across a copy of a fairly common microwave cookbook—the sort published by the appliance manufacturer to make a few extra dollars. By then, it was habit for me to flip through the pages looking for a lost treasure, and this book didn't disappoint. Near the end of the book, I spread the pages to discover a very large marijuana leaf, dried and pressed and in perfect condition. There was something about a pot leaf stuck inside this hurry-up cookbook that sent me into hysterics. I had visions of the impatient stoner, desperate with hunger, reaching for the book and marking a recipe with the item closest at hand. This was one find I just had to share.

I took a quick picture of the leaf and the book, and emailed it to a few friends. They thought it was hilarious, and they made me promise to send along any other interesting finds. I eventually set up a very simple blog in 2007, and started posting everything I found. Nearly one thousand posts later, I am now certain that I am not the only one with an interest in forgotten bookmarks.

As in the blog, I've tried to present the material in this book more like a museum curator than a critic. Reproducing the bookmarks, and the books that accompany them, with a minimum of comment, lets you see the photos, postcards, and oddities as they were when I found them.

When needed, I have transcribed the letters, cards, notes, and other written material as it appears, except in a few cases where the writer's poor spelling or grammar has rendered it unintelligible. I have probably made a few mistakes when trying to decode people's handwriting, but I've done my best to be faithful to the originals.

Photographs

Class Photo

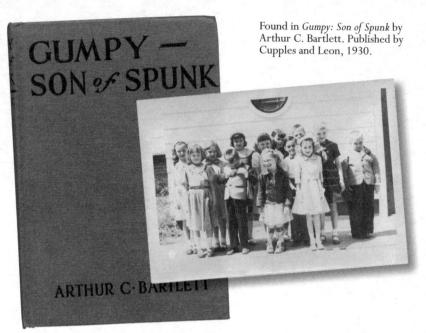

Found in *Gumpy: Son of Spunk* by Arthur C. Bartlett. Published by Cupples and Leon, 1930.

All the Young Dudes

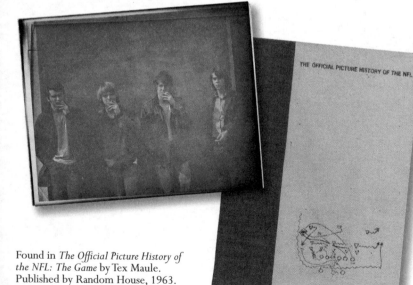

Found in *The Official Picture History of the NFL: The Game* by Tex Maule. Published by Random House, 1963.

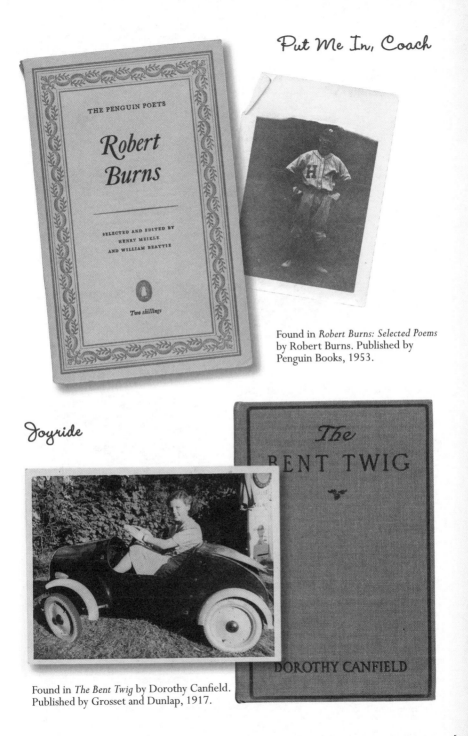

Put Me In, Coach

Found in *Robert Burns: Selected Poems* by Robert Burns. Published by Penguin Books, 1953.

Joyride

Found in *The Bent Twig* by Dorothy Canfield. Published by Grosset and Dunlap, 1917.

Harry

A PHOTO POSTCARD, DATED MARCH 16, 1916,
WITH THE NAME "HARRY" ON THE FRONT:

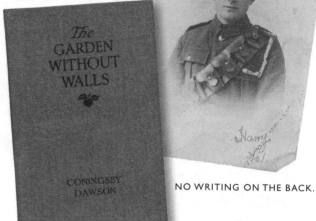

Found in *The Garden
Without Walls* by
Coningsby Dawson.
Published by Grosset
and Dunlap, 1914.

NO WRITING ON THE BACK.

The Swimmers

A PHOTO POSTCARD. THE LETTERING ON
THE SHIRTS READS "KENSINGTON BATHS":

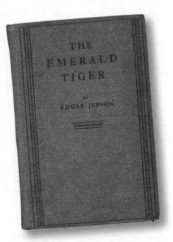

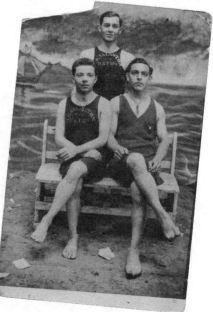

Found in *The Emerald Tiger* by Edgar Jepson.
Published by A. L. Burt, 1928.

NO WRITING OR POSTMARK ON THE BACK.

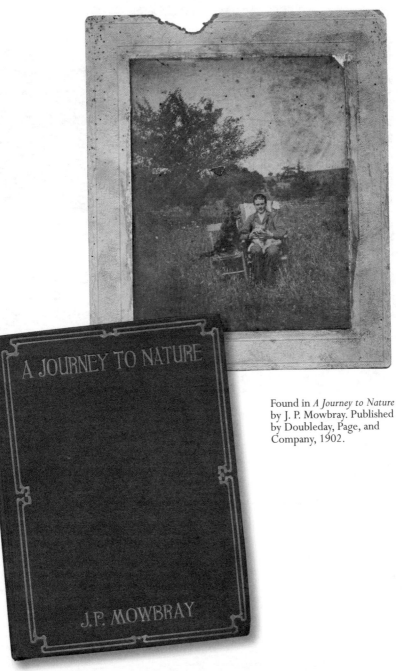

Found in *A Journey to Nature* by J. P. Mowbray. Published by Doubleday, Page, and Company, 1902.

A PHOTO ON THICK GILT-EDGED CARDBOARD BACKING:

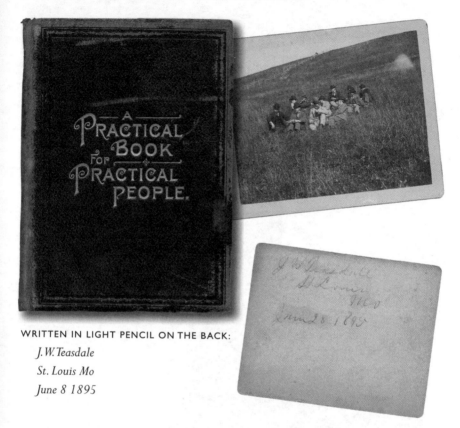

WRITTEN IN LIGHT PENCIL ON THE BACK:

J. W. Teasdale
St. Louis Mo
June 8 1895

John Warren Teasdale, born in Virginia in 1838, came to St. Louis in 1854 and founded a successful dried fruit business. His daughter was the poet Sara Teasdale, who was awarded the first Pulitzer Prize for poetry in 1918.

Found in *A Practical Book for Practical People*. Published by the Eagle Publishing Company, 1895.

Information on Mr. Teasdale was found in the August 1, 1921, edition of the *St. Louis Post-Dispatch*.

A Cornell Man to the End

Found in *The Fun of It* by Amelia Earhart. Published by Brewer, Warren, and Putnam, 1932.

Family Portrait

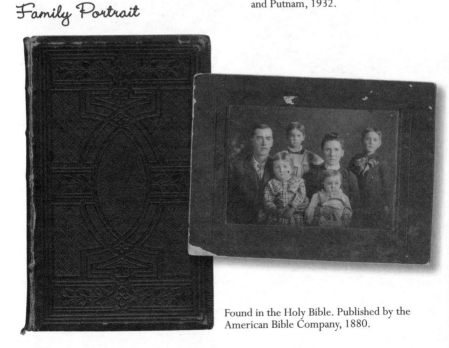

Found in the Holy Bible. Published by the American Bible Company, 1880.

The Other Girl

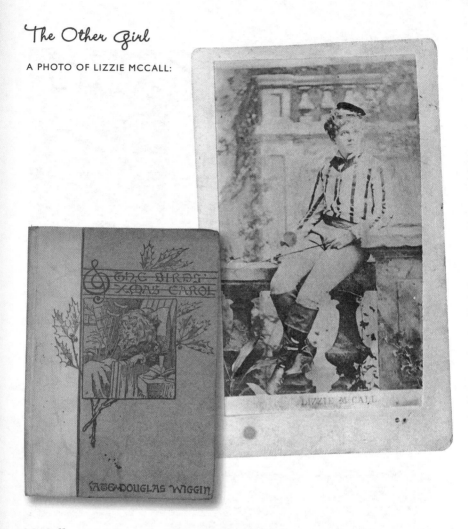

McCall was an American actress who starred in many Broadway productions as well as several feature films.

Found in *The Birds' Christmas Carol* by Kate Douglas Wiggin.
Published by Houghton Mifflin, 1893.

Float

A PHOTO OF A PARADE FLOAT:

WRITTEN ON THE BACK:

Santa Barbara Calif.
Taken in a small park
Several floats that had been
used in July 4th parade.

Found in *The Boxcar Children* by Gertrude Chandler Walker. Published by Scott Foresman and Company, 1942.

Two Tintypes

TWO TINTYPE PHOTOGRAPHS:

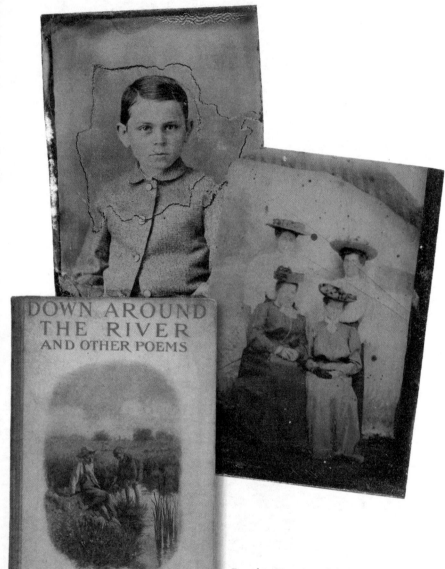

Found in *Down Around the River and Other Poems* by James Whitcomb Riley. Published by the Bobbs-Merrill Company, 1911.

On the Road

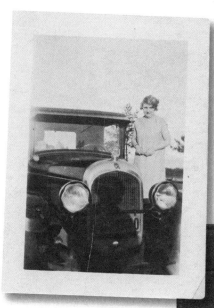

Found in *Lives of the Poets: Volume One* by Samuel Johnson. Published by the Oxford University Press, 1946.

The Band

The writing on the back indicates that it is for Decoration Day 1915, and lists the names and instruments of the band.

Found in *Animal Farm* by George Orwell. Published by Harcourt Brace, 1946.

Motoring

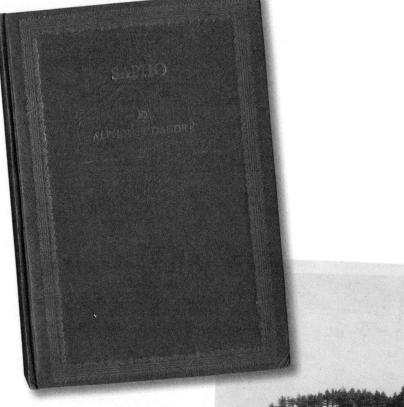

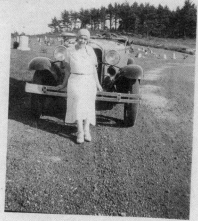

Found in *Sapho* by Alphonse Daudet.
Published by Appleby and Company,
1939.

Terror, Destruction, and Death

From what I can gather, these pictures were taken, or at least collected, by Walter G. Ross, the author of the book they were found in. The envelope bears his name, and the handwriting on the photos seems to match up with the inscription in the book (it was signed and dated by the author).

Ross might have been part of a relief effort that took place in May 1902 in Martinique, and in particular St. Pierre. Mount Pelée, a stratovolcano, erupted in early May, and eventually killed thirty thousand people. It is considered the worst volcanic disaster of the twentieth century.

The first picture is the envelope the pictures were found in, and then the book *Historical Background of the Panama Canal* by Walter G. Ross, 1947, with a blueprint of the relief ship, the S.S. *Dixie*. You can read Ross's name at the lower left.

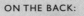

ON THE BACK:

Supplies on Martinique Relief Expedition

Commissary's supplies	990	tons
Quartermaster "	200	"
Medical "	60	"
	1250	"

The still-smoldering Mount Pelée.

ON THE BACK:

Mt. Pelée	*Eruption*
Martinique	*May 8th 1902*
4200 ft	*May 20th 1902*

The aftermath.

ON THE BACK:

Burning dead Bodies
25000 lives lost

ON THE BACK:

"Not one stone shall be left upon another"

St. Pierre, Martinique
May 21st 1902

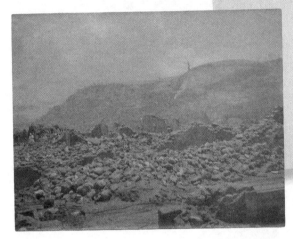

ON THE BACK:

St. Pierre, Martinique
Lava, mud, and dust.

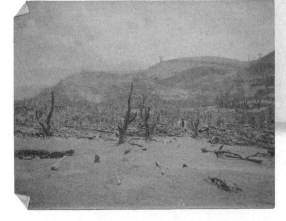

Terror Destruction and Death

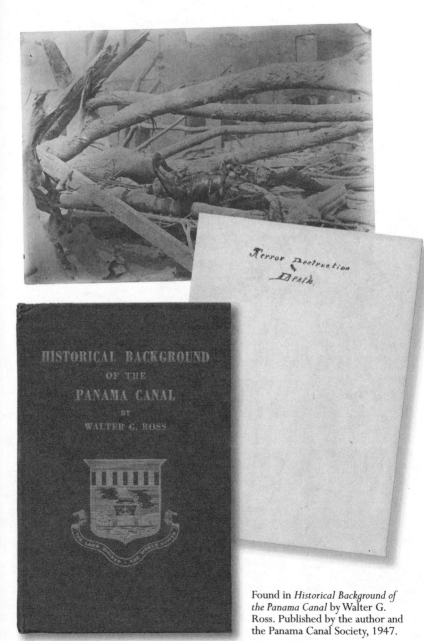

Found in *Historical Background of the Panama Canal* by Walter G. Ross. Published by the author and the Panama Canal Society, 1947.

Dorothy

TWO PHOTOS:

ONE SIGNED "DOROTHY,"
THE OTHER SIGNED "FOR
AULD LANG SYNE,
DOROTHY."

Dorothy

ECLECTIC READINGS

THE
GOLDEN
FLEECE

NEW YORK · CINCINNATI · CHICAGO
AMERICAN · BOOK · COMPANY

Found in *The Golden Fleece: More Old
Greek Stories* by James Baldwin.
Published by the American Book
Company, 1905.

A Real Navy Man

Dennie,

*Best of everything to a real Navy man. Be good
and stay out of trouble. Don't break all of the
girls' hearts. Drop me a note if you get time.
Hope you don't get seasick. Have fun.*

Love,
Betty Jean

Found in *Genesee Fever* by Carl Carmer.
Published by D. McKay Company, 1971.

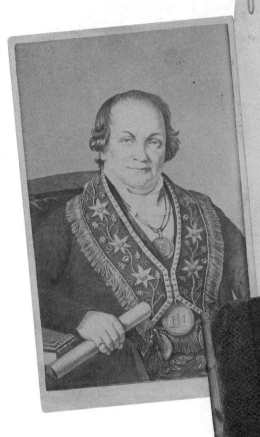

J. M. Slaney

J. M. SLANEY,
PHOTOGRAPHER,
No 731 South Second Street,
PHILADELPHIA.
—O—
Ambrotypes and Daguerreotypes
Copied into Photographs.
Photographs Painted in every
Style.

Found in *Centennial History of Delaware
County New York*, edited by David Murray.
Published by William Clark, 1898.

The Lunn Sisters

Pauline Louise Lunn
5 yrs. old
Sept 27, 1917

Marguerite Elizabeth Lunn
18 mos old
Oct 1. 1917

Taken Aug 22, 1917

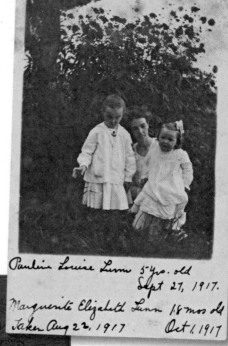

Found in *Vanity Fair* by William Thackeray. Published by John W. Lovell, no date, circa 1880.

Lost in Thought

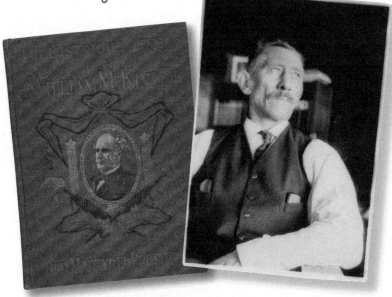

Found in *The Illustrious Life of William McKinley, Our Martyred President* by Murat Halstead. Published by the author, 1901.

Souls

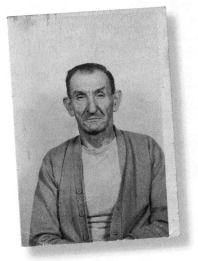

Found in *Dead Souls* by Nikolai Gogol. Published by the Modern Library, 1936.

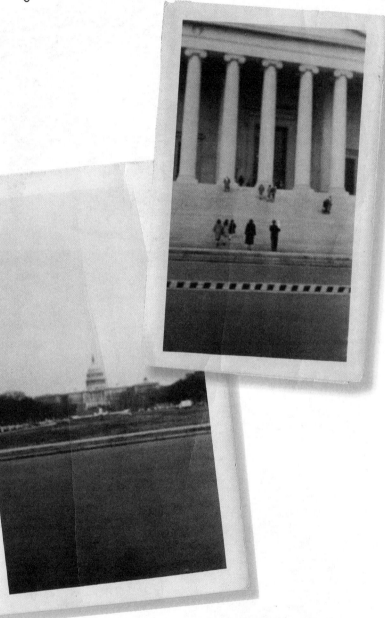

Found in *Intimate Character Sketches of Abraham Lincoln* by Henry
B. Rankin. Published by J. B. Lippincott Company, 1924.

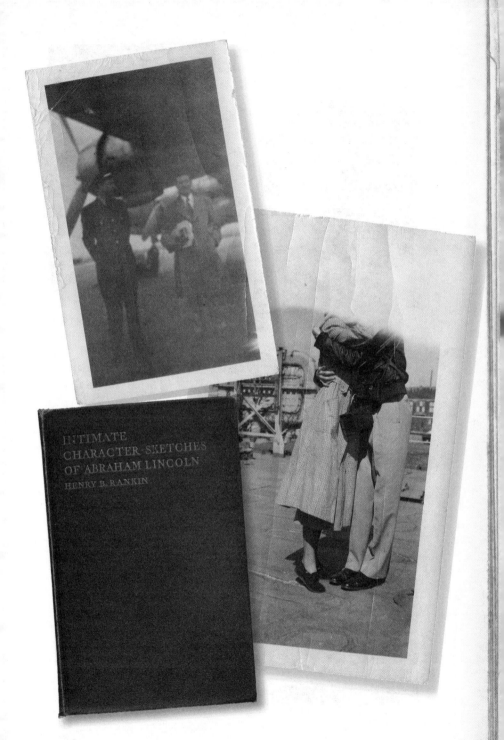

Dog-eared

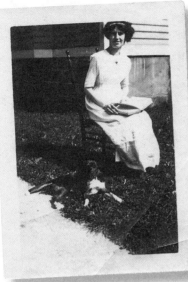

Found in *The Stem of the Crimson Dahlia* by James Locke. Published by Moffat, Yard, and Company, 1908.

Troika

A TINTYPE PHOTOGRAPH:

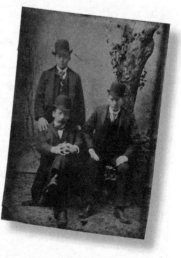

Found in *The Wing-and-Wing* by James Fenimore Cooper. Published by Frank F. Lovell, no date, circa 1900.

Letters, Cards,
and Correspondence

Dear ███,

I cannot believe what a slime you are. What clever saw in you is beyond me. Sarah's mind must be warped— I love her but how she managed to spend 2 years with a manipulative sadist like you is incredible (Yes she told me.) You must have seen that she was sad or something and zoomed in on her like a vulture. I almost feel like that's what you did to me although it was probably more my stupidity than anything else.

How could you be so CRUEL to ███ and I as to tell her that. (███ told me.) Did you want to hurt us? What did we ever do to you, slime? Did you just forget that we made a pact not to mention this woicrous flirtation? My God, WHAT did I ever see in you? You're nothing but a self-satisfying walking mass of ego, a phony!!! And the most ridiculous part of it all is that you're not even worth the trouble! You're downright ugly and you talk funny. You don't know how to dress. You have all the morality & sentiment of a JUNGLE BEAST. LESS!!! And you're a colossal snob; a boor. and a boring old fart. We won't even go into your sexual perversities —you nasty voyeur!

All I can say to you now is I hate you, I hate you, I hate you and if I ever lay eyes on you again you had better hope to God that your eyes are not within scratching distance ot my nails. And I want 'Avalon' back. ——→over, creep

Not and never will be either—

Yours—

███

Scratching Distance

Dear ------,

I cannot believe what a slime you are. What I ever saw in you in beyond me. -----'s mind must be warped—I love her but how she managed to spend 2 years with a manipulative sadist like you is incredible (yes <u>she told me</u>.) You must have seen that she was sad or something and zoomed in on her like <u>a vulture</u>. I almost feel like that's what you did to me although it was probably my stupidity than anything else.

How could you be so CRUEL to ----- and I as to tell her that (-------- told me). Did you want to hurt us? What did we ever do to you, slime? Did you just <u>forget</u> that we made a pact not to mention this LUDICROUS flirtation? My God, WHAT did I ever see in you? You're nothing but a self-satisfying walking mass of ego, a phony!!! And the most <u>ridiculous</u> part of it all is that you're not even worth the trouble. You're downright <u>ugly</u> and you talk funny. You don't know how to dress. You have all the morality & sentiment of a JUNGLE BEAST. LESS!!! And you're a colossal snob; a boor and a boring old fart. We won't even go into your sexual perversities— you nasty voyeur!

All I can say to you now is I hate you, I hate you, I hate you and if I ever lay eyes on you again you had better hope to God that your eyes are not within scratching distance of my nails. And I want 'Avalon' back.

→ over, creep.

Not and never will be either—

Yours—

----.

Found in *While Waiting* by George E. Verrilli, MD. Published by St. Martin's Press, 1993.

The Best Story of All

A GREETING CARD IN THE SHAPE OF A BOOK:

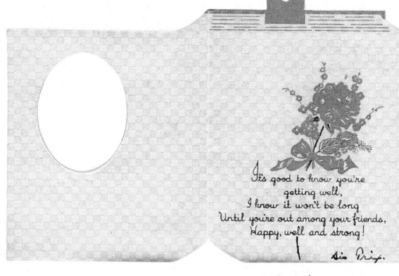

It's good to know you're getting well,
I know it won't be long
Until you're out among your friends,
Happy, well and strong!

ON THE SPINE:

The Best Story of All

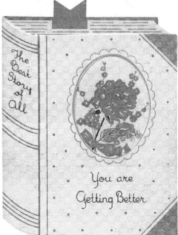

The Best Story of All

You are Getting Better

Found in *Upton Sinclair Presents William Fox* by Upton Sinclair. Published by the author, 1933.

By All Means

A HANDMADE VALENTINE'S DAY CARD:

INSIDE:

You have a frank generous and impulsive nature. Soon you will receive a letter offering you a life position. However think this matter over deeply before deciding as the person who wrote it is very deceitful. Beware of light people as they will cause you trouble.

Two weeks from tonight you will receive a letter asking you to go for a ride. By all means go as you will meet some one who you have been wishing to see. This person will give you good news. You will be married at the age of twenty-five to a mechanic.

Found in *Curve: The Female Nude Now* by Meghan Dailey, Jane Harris, and Sarah Valdez. Published by Universe Publishing, 2003.

My Dearest Friend

A LETTER AND ENVELOPE:

Jan 30th 1882

Dear Jennie

Are you going to get married, you my dearest friend? Who will I have to come to when I come home! You won't be my most intimate friend then still you might be if you wished but any body always changes when they are married. Oh Jennie you young girl to get married. Still I don't blame you every body's getting married so it makes me want to I might begin to look around for a husband. Can't you send me one?

Oh I should like to come up to the wedding if I possibly can but I am afraid it will be impossible for me to come but I will come if I possibly can come I wouldn't miss it for anything can't you come down here on your wedding tour we will try and make it as comfortable as we can on the boat and show you all over New York.

What are you going to be married in (don't think me to inquisitive you know me). Oh to be married. Just think of the first night. Oh Jennie do write and tell me about the coming wedding right away.

Found in *Sabbath Poems or Holy Day Recreations* by
Robert Rochfort. Published by Charles Daly, no date.

Ma?? says she shouldn't wonder that I can come up but if I come up I have got ?? up there and do to school and I don't want to begin school up there.

OTHER PAGE:

Jennie I am none the worse for coming down here for I don't go to any dances or parties ??? I have had invitations though.

ENVELOPE:

I just received your letter to night and was in this please write me all about the coming event. Oh naughty girl that you didn't tell me before. Can't I be your best intimate friend still I have never wronged you.

Just Dancing

A SHORT POEM, OR SOME SONG LYRICS:

Some day I'll be dancing, just
dancing round and round.
In that disco with the musical sound,
And that dream that I wished,
would always come true.
Just faded away in the clear ~~just dissapper~~ blue.

Found in *When the Stars Come Out* by Robert
Baker. Published by the Junior Literary Guild
and the Viking Press, 1934.

Candy or Peanuts

A HANDWRITTEN INVITATION:

Found in *The Stolen Child; or, Twelve Years with the Gypsies*. No author listed. Published by the American Tract Society, 1868.

Miss Emma Esty

Will be happily surprised to see her friends Tues, even, March 18th, 1879, meeting place at Miss Linda Roberts "precisely" at 7 o'clock.

Please furnish Candy or Peanuts.

People Are My Interest

A LETTER WRITTEN ON M.S. *BERGENSFJORD* CRUISE SHIP STATIONERY:

My dear Prichard,

A few things to say which a(re) better put when well thought than when clumsily and immediately spoken.

1. Of all the people aboard this ship, and indeed of all people, I enjoy your company the most.

2. As for the dancing—if you feel that I should be dancing, don't base it on the fact that because young people are dancing that I should be. If I happen to be asked, I probably will be glad to accept. On the other hand, I think I could arrange a dance if I wanted to badly enough.

3. I feel neither "crippled," limited, "confined," or left out.

4. I have danced a great deal and will no doubt do a great deal more.

5. People are my interest—and becoming acquainted with nice older people is just as pleasant as dancing with some young punk or gigolo who is being paid to make me temporarily pleased with myself.

6. Often the things that happen most slowly happen best.

7. Mrs. Casperson and Ms. Morse have both commented on what a nice person you are.

8. I'm kind of fond of you myself.

N·A·L M/S **BERGENSFJORD**
DEN NORSKE AMERIKALINJE
(THE NORWEGIAN AMERICA LINE)

LUFTPOST

My dear Richard,

a few things to say which a letter puts often well thought than when clumsily & immediately spoken.

1) *Of all the people aboard this ship, & indeed of all people I enjoy your company the most.*

2) *As for the dancing - if you feel that I should be dancing, don't base it on the fact that because young people are dancing that I should be. If I happen to be asked I probably will be glad to accept. On the other hand I think I could manage a dance if I wanted to badly enough.*

3) *I feel neither crushed, limited, confined or left out.*

4) *I have danced a great deal & will no doubt do a great deal more.*

5) *People on my interest — and becoming acquainted with nice older people is just as pleasant as dancing with some young snob or gigilo who is being paid to make out temporarily pleased with myself.*

6) *Often the things that happen most slowly, happen best.*

7) *Mrs. Coppercorn & Mrs. Rose have both comment on what a nice person you are &*

8) *I'm kind of fond of you myself.*

Found in *Van Gogh: Paintings and Drawings*. No author listed.
Published by the Metropolitan Museum of Art, 1949.

Lance

A LETTER, NO DATE
INCLUDED, BUT THE
NOTE AT THE END
INDICATES IT WAS
WRITTEN IN THE 1960S
WHEN THE AUTHOR
WAS IN THE ARMY:

Dear Mom

Well I'm sorry I haven't written before this but you know how it is just can't stand to write letter.

This place down here is a real zoo you wouldn't believe it. I've been going down to Washington D.C. a lot. Not much to do anywhere around here. I'm going to try to get home for a week in august. Don't when for sure—yet but will let you know. I'll try to get down for a few days.

You probably heard that Jane had a baby girl. It was tiny but I guess it will be O.K. and all.

Have you heard anything about my driver's license? I had them change the address for down there. If it came in please send it to me cause I need it. If it hasn't come in would you see if you can get me a temporary license or find out what happened to it. I put in the stub from the money order I used maybe that will help. I sure would hate to have to take a road test again. Couldn't pass it if I tried.

Well that's about all the news from down here not much more to say.

Love
Lance

Found in *The Young (Jung) Families of the Mohawk Valley*, edited by Clifford Young. Published by the editor, 1947.

Elephants

A POSTCARD, POSTMARKED
BROOKLYN, NEW YORK,
SEPTEMBER 24, 1907:

PRINTED ON THE FRONT:

Training the baby elephant: Central Park, New York

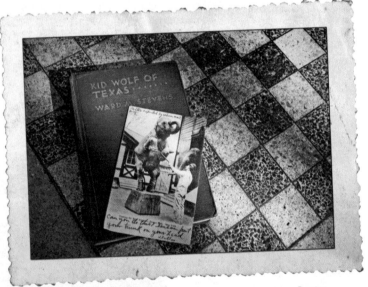

Brit Worgan

HANDWRITTEN ON THE FRONT:

 Letter expected by return mail.

 Can you do this? I mean put your trunk on your head

 Dallas

Found in *Kid Wolf of Texas* by Ward M. Streeter.
Published by Chelsea House, 1930.

This Year of Great Depression

A LETTER:

New York Dec. 31

J.G. Merritt

Dear Sir

Enclosed find check for fill there is no one that regrets the delay more than I but I hope before another New Year to have all my debts paid. I feel very much encouraged having paid five thousand dollars since May 1 in this year of great depression.

Yours

D.M.Wygant.

Found in *Mrs. Craddock* by W. Somerset Maugham. Published by the George H. Doran Company, circa 1922.

Dearly Beloved

BARNABAS BROWN ESQUIRE
POST OFFICE NEW BERLIN
COUNTY CHENANGO
N. YORK

New York 20th Octo 1826
No. 416 Broome Street
direct to me at this house its
 near Broadway ½ a mile
 North of the City Hall

Dearly Beloved,

I have wrote thee once since I Received thy letter of 25th March. I am in Tollerable good Health for one that has Traveled so many years towards the blessed end of all things here, I view the Approach towards eternal Rest with more pleasing comfort, that [sic for "than"] I ever did the arrival in port of any Voyage I ever went, I have Lived two years over the time Layd down in the Book for human life and I think their is very few that have past through so long a life with more peace of mind than I have done.

I have sold my farm at New Rochelle finding it too burthensome at this time of Life to have such a Charge and Care have none but hired people about me, the Crops in all this quarter is very good & fruit extra fine and it's a general time of health and a great plenty of the good things of this world at Market. My Love to Wife and children.

Will Turpin

Found in *The Works of P. Virgilius Maro* by Levi Hart and V. R. Osborn. Published by Joseph N. Lewis, 1833.

Dearly beloved

New York 20th Octo 1826
No 416 Broome Street
direct to me at this House its near
Broadway ½ a mile North of the City Hall

I have wrote

thee once since I Recived thy Letter of 25th March
I am in Tollerable good Health for one that has
Travelled so many years towards the blessed end of all
things here, I view the Approach towards eternal Rest
with more pleasing comfort, that I ever did the Arrival
in port of any Voiage I ever went, I have Lived two years
over the time Layd down in the Book for human Life
and I think their is verry few that have past through
So long a Life with more peace of mind than I have done

I have Sold my
farm at New Rochelle fending it too burthensome
at this time of Life to have Such a charge & care had
none but hired people about me, the Crops in all this
quarter is verry good & fruit extra fine and its
a general time of health and a great Plenty of the good
things of this world at Market my Love to Wife
and Children

Will'm Tuspin

Barnabas Brown Esquire
Post Office New Berlin
County Chenango
N York

An Obscure and Difficult Case

149 Washington Ave.,
Albany. N. Y

Oct. 31 1904

My dear Doctor Whiteford

Many thanks for sending Mr. Groff to me. His case is an obscure and difficult one. I have examined him with much care. The only organic disease which I can discover is an iritis of the right eye, for which I should advise atropine in eye and shading from strong light, also an enlargement of the heart and a doubtful mitral regurgitation. His arm symptoms are I think functional due to straining them by too hard work. The foradic current applied to the forearms and hands would be of benefit in addition I should apply a blister 2 inches square at the lower part of the cervical spine.

Medicine the medicine prescription. Substitute for it pills after each

He is work than idl

I shall b to learn of the progress of the case and to give you at any time any aid in my power.

Faithfully yours

Henry Hun

My dear Doctor Whiteford,

Many thanks for sending Mr. Groff to me. This case is an obscure and difficult one. I have examined him with much care. The only organic disease which I can discover is an iritis of the right eye, for which I should advise atropine in eye and shading from strong light, also an enlargement of the heart and a doubtful mitral regurgitation. His arm symptoms are I think functional due to straining them by too hard work. The faradic current applied to the forearms and hands would be of benefit in addition I should apply a blister 2 inches square at the lower part of the cervical spine.

Medicinally I should give him the medicine for which I enclose a prescription. Later I should substitute for it 2 triple valerianate pills after each meal.

He is much better at light work than idle.

I shall be glad to learn of the progress of the case and to give you at any time any aid in my power.

Faithfully yours

Henry Hume

Found in *Functions and Diseases of Woman* by L. C. Warner, MD. Published by Truair, Smith, and Company, 1873.

Father's Day

A HANDMADE FATHER'S DAY CARD IN THE SHAPE OF A TIE.

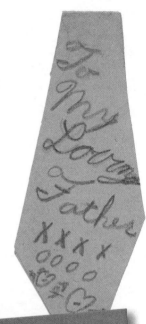

ON THE FRONT:

To My Loving Father
XXXX
OOOO

INSIDE:

Happy Father's Day!
I hope you have a nice Father's
Day I will try to be good.

Found in *The Continental Tales of Longfellow* by Henry Wadsworth Longfellow. Published by Story Classics, 1948.

Freshman Class

AN INVITATION WITH A COLOR ILLUSTRATION:

We are going to have a party

on Friday evening, April 27

Will you come?

To Anthony Memorial Hall

From Eight until Ten

—Freshman Class

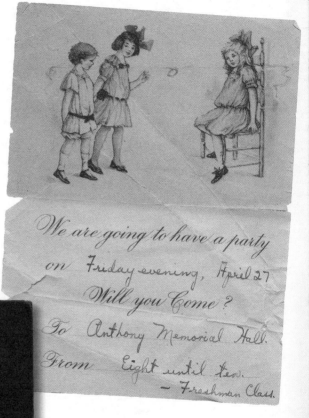

Found in *Epochs of American History: Volume Three* by Woodrow Wilson. Published by Longmans, Green, and Company, 1918.

Surgery Is Just Like Dressmaking

A LETTER ON NASSAU HOSPITAL NOTEPAPER:

104 Mineola Boulevard
Mineola NY
February 28 / 33

Dear Babe,

Thought I was going to get into the city last week and discuss operations with you but looks like I didn't. Am working now but don't think it will last long.

Have you set a date for your party and where is it "gonna" be? Helen said you were thinking of Fifth Ave. Hospital which is a pretty nice place. Class—

Polyclinic is also a good hospital although I don't remember ever being in there.

Do let me know the date you are planning so that I can also plan to be on hand—not that I'm such a hot nurse but maybe a familiar face and a whiskey tenor will help smooth over the first few days. Don't worry about it—remember surgery is just like dressmaking—a clip here and a stitch there and only a dumb amateur could put a sleeve in a neck (I'm thinking of my early days of summer organdy).

Write soon

Love, Florence

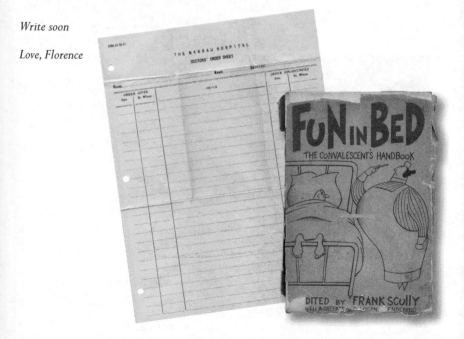

104 Mineola Boulevard
Mineola, N.Y.
February 28/33

Dear Babe,

Thought I was going to get into the city last week and discuss operations with you but looks like I didn't. Am working now but don't think it will last long.

Have you set a date for your party and where is it gonna be? Helen said you were thinking of Fifth Ave. Hospital which is a pretty nice place — class — Polyclinic is also a good hospital although I don't remember everything is there.

Do let me know the date you are planning so that I can also plan to be on hand — not that I'm such a hot nurse but maybe a familiar face and a whiskey temp will help, smooth over the first two days. Don't worry about it — remember surgery is just like dressmaking — a clip here and a stitch there and only a dumb amateur could put a sleeve in a neck (I'm thinking of my early days of summer organdy) Write Im

Love Florence

Found in *Fun in Bed: The Convalescent's Handbook*, edited by Frank Scully. Published by Simon and Schuster, 1933.

Gilberte E. Walker

A SMALL ENVELOPE WITH AN ILLUSTRATION PASTED ON.
THE NAME CARD INSIDE READS "GILBERTE E. WALKER":

Gilberte E. Walker.

Found in *The New Testament of Our Lord and Saviour Jesus Christ*. Published by the British and Foreign Bible Society, 1832.

Jest

A LETTER, DATED SEPTEMBER 19, 1883, WRITTEN ON THE STATIONERY OF FRANK W. ELWOOD AND COMPANY, BANKERS AND BROKERS, ROCHESTER, NEW YORK:

As you adopt the method of "challenging" in vogue with Courtney, Sullivan and co., instead of as among gentlemen, and to not accompany your challenges with the customary prize named and forfeit money, I must regard it as a jest. Further, I have too much else to do and think of at present to bother about rowing you; but since you have so much leisure time for sports and pastimes at your bank, would suggest you're getting up a race with some of the boys of your age.

F. W. Elwood

To: W. E. Perkins

Found in *The Poems of John Greenleaf Whittier*. Published by Thomas Y. Crowell, 1902.

This Old World

American Aviation
35 Eaton Place
London

England
18-4-18

Dear Uncle and all,

Have thought of you all many time since I have been over here in this old world. It sure is an old world but is mighty exciting right now for everyone here. I tell you Uncle George war is hell just as Robt. E. Lee said and I will certainly be glad when it is all over and I return home once more but there is about at [censored] and if so I will go down and see him. Mother also spoke about Harold not having to get into it just yet and I hope he will never half to come to the front. For before this war is over there wont be very many cousins left I expect to be pushing daisies up before summer is over, but I try and keep Mother looking on the bright side of life which I know is hard for her but she has to remember that her son is not the only one at war that there is many other mothers worrying to night. As much chance as a feather in a sand storm. Ha. I wanted to get leave at New York to come and see you for a day or so but was impossible.

I have been in England about three months training with the Royal Flying Corp. and expect to leave here now for the front most anytime and when a person gets their its only a chance of luck. Read a letter from Mother today and she said that Clare had been wounded in action was sorry to hear that am trying to locate him now he might be in the military hosp.

The weather here has been very bad lately it has rained for nearly two weeks and to-day it snow quite a bit. No weather for flying.

Have had several trip about England was to London twice also Manchester and there are certainly a great many sights to see here London is nothing like New York but it's a great city for an antique city. Saw Westminster Abby—London Bridge—Tower—St. Paul Cathedral which is a wonderful sight. Could tell you the many interesting things but you know we aren't allowed to say to much. Hoping this letter will find you all well and happy and am as ever your nephew Clifford.

Love to all

THE ENVELOPE:

Mr. George West

Rhinebeck, New York

Hill Top Farm

Solider Mail

ON THE BACK:

OPENED BY CENSOR 3284

Found in *The Mill on the Floss* by George Eliot.
Published by Scott Foresman and Company, 1916.

Added Joys

AN ANNIVERSARY TELEGRAM, DATED JUNE 25, 1938:

SYAD165 FT=LITTLEFALLS NY
MR AND MRS ERNEST GAFFNEY
24 DRAPER ST HO
 *CONGRATULATIONS ON YOUR ANNIVERSARY MAY EACH NEW ONE BRING
ADDED JOYS.*

 GERTRUDE MORGAN.

Found in *Lanterns in the Night* by Paul Eldridge.
Published by Haldeman-Julius, 1945.

Santa's Sweetheart

A CHRISTMAS CARD WITH MATCHING ENVELOPE. THE FRONT OF THE ENVELOPE READS "FOR SANTA'S SWEETHEART":

INSIDE:

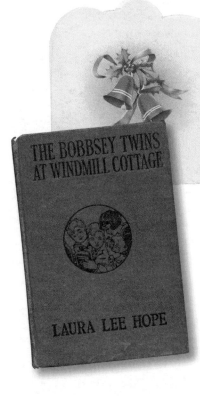

May this friendly
Christmas token
Do its intended bit
In expressing happy wishes
That go along with it
Your Loving
Daddy

Found in *The Bobbsey Twins at Windmill Cottage* by Laura Lee Hope. Published by Grosset and Dunlap, 1938.

Good Times in Lewisburg

A LETTER FROM THE STATE HOSPITAL FOR THE INSANE, NORRISTOWN, PENNSYLVANIA:

My dear Minor;——

Your letter was received some time ago and since then all of you have been having a good time in Lewisburg. I wish I could have been there too.

I have been very busy lately. Busier than I could wish. I hope it will let up now.

Enclosed you will find a check for $61.85, which according to your account leaves me an even $400 to pay.

Hoping that you had a pleasant time in Lewisburg. I am,

With love to all,
Mary

I have no I.R. stamp so enclose another.

Found in *The Yearling* by Marjorie Kinnan Rawlings. Published by Charles Scribner's Sons, 1938.

Respectfully Invited

A HANDWRITTEN INVITATION:

You are respectfully invited to attend a surprise party at Ray Caldwell's.
Meet at 6½ O Clock at Charlie Crothers.

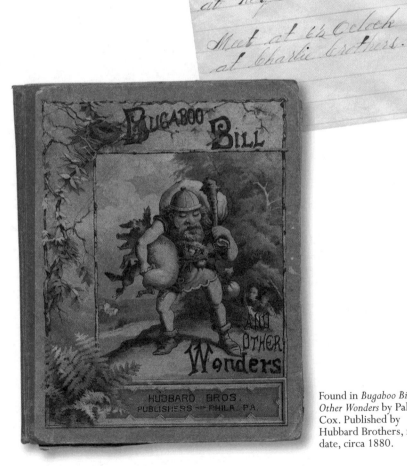

Found in *Bugaboo Bill and Other Wonders* by Palmer Cox. Published by Hubbard Brothers, no date, circa 1880.

If a Fellow Really Loves a Girl

A LETTER, DATED JULY 24, 1917, ARLINGTON, NEW JERSEY:

Arlington N. J.
July, 24 1917

Dear Mother;

I suppose that you think I have forgotten you but far from it. I have been thinking of you every day but really I have been so busy during the day that when it came night I was so tired that I could not write, but to day they let us offe easy, & although I am very tired I will try to make up for lost time

I have not yet had an answer from my last letter but I received the book all O. K. & also the papers this morning. But I wish you ... you gave me before I left.

In the first place I was required to have my teeth fixed which will cost me $20.00 exactly. I went to the army doctors but all they wished to do was to extract them so I went to another dentist and he is fixing them up. I have got to have three bridged in which cost me $5 a piece.

Now I will tell you exactly what became

... really Mother ... it will make ... Mother you ... really ... any way. ... if you ... I am ... be better ... said that ... contrary ... me know ... worries. ... 30 cents ... that I am ... you just ... me money

of the $60 dollars which I had when
I left home.
$5.00 in Albany for room.
$5.00 for care fare to Albany.
$5.00 for a razor.
$4.00 for a pair of leggings.
$2.50 for a compy suit.
$5.00 from Albany to N. Y.
Besides that I have had a few
little incidentals to buy. I have
been to Ossining three times.
And as I am living in Arlington
it costs something to travel back
and forth every day. You may.
ask me why I do not live at
the armory. Well there are may
tried to spend money. or to keep
the pace with the other fellows.
in such as gambling and other
things.

How is the kid. Harris & I have not
yet had any. signs of the measles.

Sonny.

Dear Mother;

I suppose that you think I have forgotten you but far from it. I have been thinking of you every day but really I have been so busy during the day that when it came night I was so tired that I could not write, but to-day they let us off easy, and although I am very tired I will try to make up for lost time.

I have not yet had an answer from my last letter but I received the book all OK and also the papers this morning. But I wish you would write.

I am very anxious to hear what you are going to say in answer to the question which I put up to you last time. I was up to Ossining Sunday to see Leah (of course) and I told her that I had written you about it.

She also is very anxious to know what you have to say. I have not yet spoken to Mr. and Mrs. Weed but Leah said she knew they were wiling that I should marry her. They seem to treat me now as one of the family.

Mother I hope you will not be angry with me for this, but really Mother if you are I do not think that it will make an awful lot of difference. For Mother you know very well if a fellow really loves a girl he will marry her any way. But I would feel much better if you would give me your consent and I am sure Leah would feel very much better for she likes you very much and said that she did not want to do anything contrary to your wishes. So please let me know your answer.

That though is only one of my worries. Just at present I am with but 30 cents in my pocket. You may think that I am very extravagant but I can tell you just what I have been doing with the money which you gave me before I left.

In the first place, I was required to have my teeth fixed which will cost me $20.00 exactly. I went to the army doctors but all they wished to do was extract them so I went to another dentist and he is fixing them up. I have got to have three bridged in which cost me $5.00 a piece.

Now I will tell you exactly what became of the $60 dollars which I had when I left home:

> *$5.00 in Albany for room*
> *$5.00 for car fare to Albany*
> *$5.00 for a razor*
> *$11.00 for a pair of leggings*
> *$2.00 for a comfy knit*
> *$5.00 from Albany N.Y.*

Besides that I have a few incidentals to buy. I have been to Ossining three times and as I am living in Arlington it costs something to travel back and forth every day. You may ask me why I do not live at the Armory. Well there are many reasons why I do not. One is because the food is not very good. There is where a good deal of my money has gone. If you will come down Mother I can explain things better.

I have been saving [as much] as possible of my money; I do not like to be different from all the rest so of course I have been out to a show once or twice. I have not tried to spend money as to keep the pace with the other fellows in such as gambling and other things.

Mother if you were down here for a few days you could understand things better. Couldn't you possibly come down before we leave.

I am going to ask you to send me $50 dollars which will be the last money that I will ask you for. If you do not wish to let me have it all right. It's a very easy matter to borrow it in the Army but I do not like to do that. As it is I have got to borrow some until I hear from you.

Remember Mother you may never see me again.

We got all our supplies in to-day so we expect to leave for the South at any time. The Captain told us to-day that we might leave Sunday July 29th.

How is the kid. Harris and I have not yet had any signs of the measles.

Now Mother will you please answer my letter immediately for it is important that I should hear from you by Thursday or Saturday. Please address every thing to the Armory. If you can please come down.

Will write you again as soon as possible.

With lots of love and kisses
Sonny

Found in *The Standard American Speaker and Entertainer* by Frances Putnam Pogle and George M. Vickers. Published by W. E. Scull, 1901.

To-day's Sun

A LETTER WRITTEN ON TREASURY DEPARTMENT STATIONERY, DATED JANUARY 31, 1901:

Mrs. Geo. D. Sidway
433 Main Street
Canandaigua New York

Dear Madam:

I enclose herewith draft on New York for $20 in payment for board for Mrs. Clark during the month of January 1901. Please acknowledge receipt. We are having quite a little snow fall here but it is no good, it doesn't stay on the pavement more than a day or two, some cutters were out yesterday but to-day's sun will melt the snow before night. We are all pretty well for us and hope this will find you the same.

> *Yours truly*

> *E.B. Daskam*

According to a November 21, 1912, story in the *New York Times*, Daskam was Chief of Public Moneys Division at the U.S. Treasury Department.

Found in *Black Beauty* by Anna Sewell.
Published by W. B. Conkey, no date,
circa 1900.

Mrs. Geo. D. Sidway
433 Main Street
Canandaigua
New York

(Ed. 4-12-1900—1,000,000.) No. 18. TREASURY DEPARTMENT

January 31. 1901

Mrs. Geo. D. Sidway,
433 Main Street
Canandaigua
New York,

Dear Madam: I enclose herewith Draft on New York for $20 in payment for board for Mrs Clark during the month of January 1901. Please acknowledge receipt. We are having quite a little snow fall here but it is no good, it don't stay on the pavement more than a day or two, some cutters were out yesterday but to day's sun will melt the snow before night. We are pretty well for us and hope this will find you all the same.

Yours truly
E B Daskam

Masquerade

TWO TICKETS TO A MASQUERADE BALL:

Yourself and Ladies are Cordially
Invited to Attend a

MASQUERADE BALL
AT BULLION'S HALL
SCHUYLER LAKE, N. Y.

FRIDAY EVENING, FEB. 5, 1904
GOOD MUSIC IN ATTENDANCE

Otto Poepel of Utica will be present with a full line
of costumes and masks for rental at 50 cents to $5.00

GOOD ACCOMMODATIONS ON TROLLEY
NORTH AND SOUTH

FULL BILL $1.00

HORACE ROBERTS | Room Managers
PETER McDONOUGH |

DENNIS DORAN, Ticket Agent

CHAS. A. AYRES, PROP.

THE ELEMENTS OF GREEK

FRANCIS KINGSLEY BALL

THE MACMILLAN COMPANY

Found in *The Elements of Greek* by
Francis Kingsley Ball. Published by
Macmillan, 1903.

Unable to Pay the Full Amount

A PORTION OF A LETTER, DATED JANUARY 1, 1849:

My Dear Sir,

Allow me to inquire of you where I may find my note of $150 bearing date January 10th, 1846.

Allow me to say that the above loan kindly granted by you enabled me to prosecute my studies, and that the degree of M.D. was conferred on me at ?? ?? Medical College on the 18th of June 1846 after which married and settled at Carlisle Scho. Co. NY on the 13 July following; where I have since been doing a small but steadily increasing practice. I shall probably be unable to pay the full amount of the demand from my own resources but if payment in full is desired by you I shall contract another loan for the amount which

Found in *Johnson's Dictionary of the English Language in Miniature.* Published by D. Buchanan, 1807.

Sick

A POSTCARD SHOWING THE EAST RIVER BRIDGE, NEW YORK, DATED JANUARY 6, 1910:

ON THE BACK:

Dear Zella,

Jennie is very sick in bed ever since Monday and has the Doctor every day so will not be able to go up to your house.

> *Love to all,*
> *Jennie*

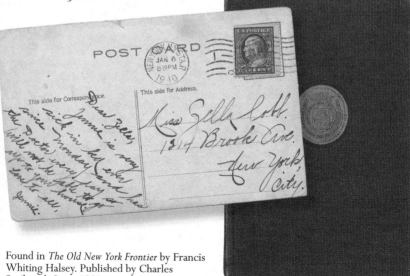

Found in *The Old New York Frontier* by Francis Whiting Halsey. Published by Charles Scribner's Sons, 1901.

Suffragette

A POSTCARD FEATURING THE U.S. HOTEL, SARATOGA SPRINGS, NEW YORK, POSTMARKED MAY 25, 1916, BLUE MOUNTAIN, NEW YORK:

ON THE BACK:

We have attended General Conference for two days and are going back Thursday.

Monday night we heard Wm. J. Bryant speak on Suffrage. Tues. I met Frank L. Brown of N.Y. and had a visit with him. He is on the same comm. with W.D. Southworth.

Mrs. H.L. Baker.

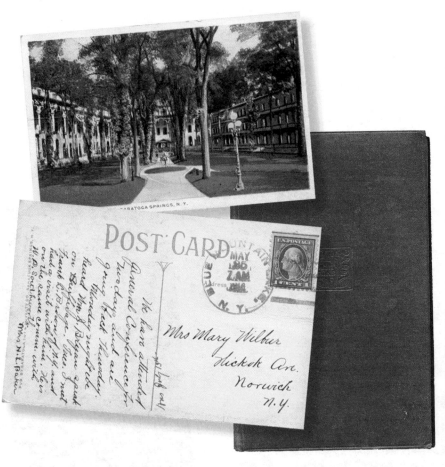

Found in *Richelieu: A Tale of France* by G. P. R. James. Published by J. M. Dent, 1911.

An Unfortunate Word

Dear William,

I would like to have a conversation with you but I am so confined at home this winter. I must take this mode to communicate a few thoughts. I am sorrow for that sentiment you uttered that Mr. Robertson objected to at the annual meeting of the congregation. I have known Mr. Robertson for many years and tho he has some peculiarities of temper yet I think him an honest and I hope a pious man.

I called on him last Saturday, he was milde and without any irritations and wished me to say to you that he entertained no hard feelings toward you on account of it, and do not wish his name farther used in the matter but still think there would have been no harm if you had withdrawn the expression for if it meant any thing at all, individual or general it must have some reference to those who have withdrawn from the church and those he referred particularly to and they had withdrawn with a clear santificate and may feel disposed some day soon to join the church again . . . but if they had any occasion to suppose that the congregation considered them to be drop it would wound their feelings and be discreditable to the church.

I have heard the opinion of two or three of your friends here and they all think its an an unfortunate word; enemies will rejoice and make use of it. I have thought it right to consult with you about the matter. We need your help in the church, and I would be someone to have your influence injured. I do not write officially but as a personal friend. Think over the matter, and let me know your second thoughts as soon as convenient.

Found in the Holy Bible. Published by B. Waugh and T. Mason for the Methodist Episcopal Church, 1834.

Dear William I would like to have Conversation with you but I am so confined at home this winter I must take this mode to communicate a few thoughts — I am sorrow for that sentiment I have uttered. That Mr Robertson objected to at the Annual Meeting of the congregation I have known Mr Robertson for many years and tho he has some precipitance of temper yet I think him an honest and I hope a pious Man I called on him last Saturday — he was candid and _____ ___ in _____ ___ _____ _____ _____ _____ that he entertained no hard feelings toward you on account of it, and do not wish his name farther used in the matter but still think there would have been no harm if you had withdrawn the expression for if it meant any thing at all, individual or reverall it must have some reference to those who have withdrawn from the Church and those he referred particularly was they had withdrawn with I ____ ____ ____ and my ____ disband one day soon to join the Church again — but if they had any occasion to suppose that the congregation considered them to be ____ it would wound their feelings and be disserviceable to the Church — I have heard the opinion of two or three of your friends here and they all think it an unfortunate word — enemies will rejoice and make use of it — I have thought it right to consult with you about the matter. we need your help in the church, and I would be sorrow to have your influence injured. I do not write officially but as a personal friend think over the matter. And let me know your _____ thoughts as soon as convenient

Be Prepared

A HANDMADE INVITATION:

Hear Ye! Hear Ye! Hear Ye!

At 7:30 prompt on Wednesday evening be prepared to meet your doom.

You are to be dressed in the following manner, and woe betide you if even the smallest point is neglected.

1. Have your hair curled in twelve curls, each tied at the top with wrapping cord.

2. Wear your "jeweled" dog collar.

3. On your right foot, wear a tan stocking and black shoe. On your left foot wear a black stocking and a tan shoe.

4. Wear a white petticoat which is exactly two and seven-eights inches longer than your dress shirt.

5. Wear a white waist, blue shirt, and a red belt.

6. Have a man's red handkerchief pinned by one corner to your belt.

7. Suspended by a cord wear our society emblem (skull and crossbones) around your neck.

Be prepared to sing "Oh Where and Oh Where is my Little Dog Gone?" and "Where is my Wandering Boy Tonight?"

Mum is the word!

You will be called for at 7:30 Wed. Oct 12, 1910.

Found in *The Aeneid of Virgil*, translated by
J. W. Mackail. Published by Macmillan, 1931.

Hear ye! Hear ye! Hear ye!
at 7:30 prompt on.
Wednesday Evening
be prepared to meet
your doom.
You are to be dressed
in the following
manner, and woe
betide you if even
the smallest point

curled in
tied at the
—ing cor#.
—d "dog collar,
—ot wear
—and black
—ot wear
—and tan
—ttit½al which
—nt even
—longer than
—!
—auch blue
—belt.
—red handkerchief
—rner to

suspen— —of a coord wear
our society emblem 🐝 around

u Be prepared to sing
"Where and Ah where!
is my little dog gone!"
and "where is my
wandering Boy
tonight!"

<u>Mum is</u> the

Word!

, , you will be called
for at 7:30 Wed. Oct 12, 1910

Too Old to Suit Me

A LETTER, DATED 1876. THE ENVELOPE BEARS TWO POSTMARKS—THUN, SWITZERLAND, AND NEW YORK, NEW YORK—1876. THE STATIONERY IS FROM HOTEL THUNERHOF:

THUNERHOF
THUN.

Thun, Switzerland
September 3rd 1876

My dear Ben

Your good long and interesting letter of 3d inst was rec'd yesterday. I never forget the 3d day of September. My Mother was born that day, Amelia was born that date and we were married on that day. I never forget Anson and the dear ones that have passed away when that day come — around which it does pretty often. We have been here in this beautiful spot for ten weeks. I think there are few prettier places in the world. It is a valley surrounded by mountains many of which are always covered with clean white snow. Just in front of the hotel is a beautiful river which runs from Lake Thun, about half a mile distant, this lake is some ten miles long and is very beautiful. But all the country is too old to suit me and then...

[remaining portions of the letter are partially illegible handwriting]

Hôtel Thunerhof
Thun.

Benjamin Manton Esq

North Anson

Maine

U.S.A.

Thun Switzerland
September 3rd 1876

My dear Ben, Your good long and interesting letter of was recd. yesterday. I never forget the 3rd day of September. My mother was born that day. Aurelia was born that date and we were married on that day. I never forget Anson and the dear ones that have passed away when that day comes around which it does pretty often.

We have been here in this beautiful spot for ten weeks, I think there are few prettier places in the world. It is a valley surrounded by mountains many of which are always covered with clean white snow. Just in front of the hotel is a beautiful river which runs from Lake Thun, about half a mile distant. This lake is some ten miles long and is very beautiful but all this country is too old to suit me and there are no trout worth fishing for. Once in a while they do catch a few, but people fish day after day without a bite. I have no doubt that two thousand years ago you might have taken quite a respectable string long the last of May or first of June, when the apple blossoms were out, but give me Pleasant Ridge for fishing yet. There is a quiet and stillness there that you do not find here, there are too many people here.

I think it was nineteen years ago that Stearns and I went to Pleasant Ridge with you and I have missed going there but few years since and I have enjoyed a great deal there and we have had lots of good times and I am not aware that any one of us have ever been made the worse for going. We have dug a few stumps possibly for slight indulgences but when the stump was out by the roots, we had to be rewarded and often we would feel like digging out another. I think we may have to increase that penalty to two stumps.

I was very much disappointed that I could not come last spring. Had I come as I expected then time table would have held good for the Stearns was it in time and we would not have hurried five minutes. The boys in Boston were ready and I have no doubt that we would have had a time.

Luis Darforth gave me an agreeable surprise a few weeks ago by coming into the hotel one night, he told me that he was going to give up his Centennial trip for the sake of going to Pleasant Ridge with us.

We leave here for Paris tomorrow and we now expect to return to Boston next June. It will too late for Spring fishing but possibly we can take a little private ? later in the season.

Taylor is home again and writes me that they are going down fishing next Spring. If they go you will have a good time. I always feel so sorry when I think we can never see poor Collin's genial face there again, no better or larger heart ever been about our camp fire. I am sorry that they have so many boats and such cheap fare into the Ridge. I think it must be bad for the trout but still there will be fish there for a great many years.

Tell Bill to get a few down into the South Cove and have them well cared for until I come home and we will go up and take them out, perhaps if he should drink a bottle St Croix that they would hand around then.

Can Bill find ? in September?

I do not think that I should like any Felkin's Motel, still you could go there for a night.

I was very glad to know that Uncle Ben suffered nothing by the fire. I was afraid that he had.

I am always so glad to hear from Anson. I never do only through you.

Em is much improved since I wrote you last. She now seems more as she used to. The children have been perfectly well this summer until last week when Willie was taken with inflammation of the bowels, but he is all right now and Saturday morning we hope to be in Paris and in another week the children will all be in school, if well. They will remain there until we start for home, which it seems to me will be but a very short time.

This is one of the loveliest days in the year and I am writing on the piazza while the snow covered mountains seems so very near to us. Still you are glad to get into a shady place.

Remember us all to Uncle Ben and Aunt Lois to Uncle Columbus and Aunt Betty. Em sends much love to you all and so do I. Let me know what kind of a time you and Bill have. The snow that I can see from here would make an awful lot of punch.

I enclose a few Swiss stamps for Ben will send some more from Paris. I also enclose a little Italian money and a Swiss cent.

From your friend
MD Spaulding

Found in *Contemporary Art in Europe* by S. G. W. Benjamin. Published by Harper and Brothers, 1877.

Central Avenue

A POSTCARD, POSTMARKED DECEMBER 21, 1954. THE FRONT FEATURES AN ILLUSTRATION OF CENTRAL AVENUE IN PHOENIX, ARIZONA:

ON THE BACK:

I don't know as I stated in my letter that the mag. is from Alice and Alfred to you both, besides us to you, Stacy.

Ethel

Found in *Will Acting Spoil Marilyn Monroe?* by Pete Martin. Published by Pocket Books, 1957.

Ridley Wedding

A WEDDING INVITATION, ADDRESSED TO MR. GEORGE LAKE AND LADY. THE
INVITATION IS THICK-STOCK PAPER WITH GILT EDGING.

Mr. and Mrs. Charles E. Ridley request the pleasure of your company

at the marriage of their daughter

Jennie E.

to

George A. Conine.

Wednesday Evening, March eleventh, at six o'clock.

Phelps, N.Y.

1885

Found in *The Prince and the Pauper* by Mark Twain.
Published by Charles Webster, 1892.

The Pool

A POSTCARD, DATED FEBRUARY 27, 1959.

THE FRONT FEATURES THE POOL OF THE FUN 'N SUN MOTEL, CLEARWATER BEACH, FLORIDA:

ON THE BACK:

Dear E—

This is where we will be, as usual. We always say it looks like Harrison in the pool. Don't you think so?

 Love DeEtta

Found in *The Great Gatsby* by F. Scott Fitzgerald.
Published by Charles Scribner's Sons, 1953.

What Do You Think?

A HANDWRITTEN INVITATION; LOOKS LIKE A FIRST DRAFT:

Mr. Roy Van Housen requests your present at his home Friday evening, November the eighth, one thousand and nine hundred and twelve.

INSIDE:

I think this would be quite nice invitation paper what do you think?

Found in *The Sinking of the Titanic and Great Sea Disasters*, edited by Logan Marshall. Published by L. T. Myers, 1912.

Do You Like It?

A VALENTINE'S DAY CARD:

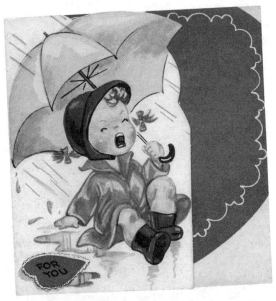

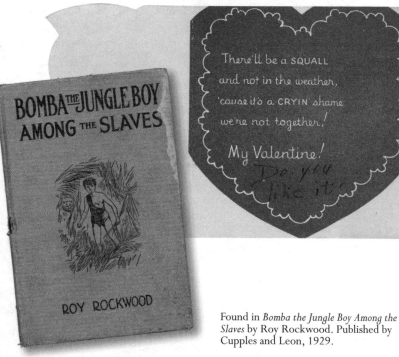

There'll be a SQUALL
and not in the weather,
'cause it's a CRYIN' shame
we're not together!

My Valentine!
Do you
like it?

Found in *Bomba the Jungle Boy Among the Slaves* by Roy Rockwood. Published by Cupples and Leon, 1929.

Present This Card at the Door

**AN INVITATION CARD ON THICK
GILT-TRIMMED PAPER:**

INSIDE:

*Washington's Birthday Party
given by
Coeu'r de Lion Lodge, No. 571
F. V.A.M.

at

Masonic Hall, Roxbury NY, Feb. 22nd, 1895.
Music by Easman's Orchestra.
Yourself and Ladies are cordially invited to attend a
Private Party at Masonic Hall, on the evening of
Washington's Birthday, February 22, 1895.
Refreshments will be served at the
Delaware Valley House.
The Committee take pleasure in announcing that
this is strictly a select Private Hop. Present this card
at the door.
Bill, including Supper, $1.50
W. G. Russell, Andrew Corbin, Harvey Suyday, Com.*

Found in *The History of the Town of Roxbury* by Caroline Evelyn More and Irma Mae Griffin. Published by the Reporter Company, 1953.

Listen, Kid

A LETTER, POSTMARKED JUNE 22, 1943, CAMP BEALE, CALIFORNIA:

Dear Earline,

Your letter has been received some time ago. Was more than glad to hear from you.

Listen please forgive me for not writing before now. I would have wrote but I have been pretty sick since I been in the hospital. But today I am some better today. Listen kid tell Ms.Wilke Mae—I said I beg her most humble deluded pardon. For I did answer every letter she wrote me but any way I'll write her again.

You ask me about when I was coming again soon, well at the time being I can't say, but I don't no. For I don't know whether I'll be able to come to New York this time or not for I promised Dad and my sisters I'd come down to see them this time.

Well how is Lewis tell him I said don't let that draft catch him tell him to shut that door.

Well I am nauseous and can't write so this is all for now. By the way I have been in the hospital for 21 days so far and I don't know how many more but my leg is a little better for I can walk around a little.

By now

Abe

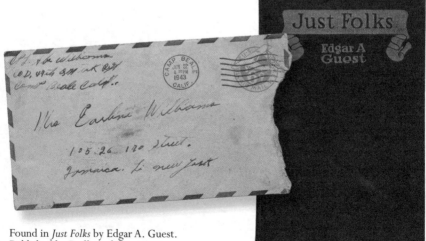

Found in *Just Folks* by Edgar A. Guest.
Published by Reilly and Lee, 1917.

CALIFORNIA
"The Land of Sunshine"

Corl. Al. Williams,
C.D. 877 Q.M. T.K. Reg.
Comp Beale Calif.

Dear Earline.
 Your letter has bin
recieved Some time ago. Was more
than glad to hear from you.
You ask me a ___ ___
Was coming ___ sister Please for give me for not writing
Well at th ___ before now. I would have wrote but
Say. but I ___ I have bin pretty sick since I bin in
No withher 2 ___ this Hostital. but to day I am Some
to ___ ___ better today. sister ___ ___ tell ___
I Promost ___ Willie Mae - I said I ____ here most
one down ___ Humble devouted Pardon. for I did
Will have a ___ answers every letter she wrote me
cant let ___ any Way I'll write here
___ Till him to ___ again.
Will I am ___ nephews un cam
Write So this is all for now
by the way I have bin in the Hostital for
21 days So for an I dont no how many
more but my leg is a little better
now for I can walk aroun a little.
By ____ ____ ____ ____ ____

FORGOTTEN BOOKMARKS [83]

There Is No Love Like Mine

A POSTCARD, POSTMARKED MARCH 10, 1911:

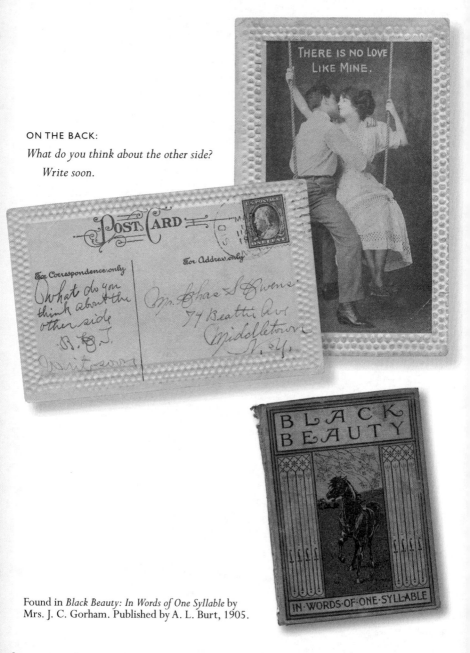

ON THE BACK:

What do you think about the other side?
 Write soon.

Found in *Black Beauty: In Words of One Syllable* by
Mrs. J. C. Gorham. Published by A. L. Burt, 1905.

3

Notes, Poems, Lists, and Other Written Ephemera

Dearest Dad

TWO PIECES OF FIVE-BY-EIGHT-INCH NOTEBOOK PAPER. THERE WERE SEVERAL
MATCHING SHEETS OF THE SAME NOTEPAPER IN THE BOOK, ALL BLANK:

Dearest Dad,

It's June 19, 1994,

 Father's Day.

 I am so glad you can get some rest, now! These people are so good at what they do, and they know how to care for you.

 I hope you will be able to get a bit better so we can still have good times, + make plans together.

 Everyone asks about you and says to give you their greetings. Many are remembering you also in prayer.

 It is very hot out today. In here it is cool and pleasant.

 The flowers in the little basket are from Peggy's garden + ours. Mother always liked poppies. So do we.

Hi! It's June 21st! You are really sleepy but you smiled at me tonight. I came later, so that you might be awake. And you were! [sort of]

 It's been cloudy today, off + on, + breezy. Storms threaten, but don't emerge. Sue has been visiting. She brought me a "personal pizza" + bread sticks for supper. [You + I] -> We went for a walk! That's a first! I'll have the TV turned on tomorrow. I'm so glad you're getting rested. People ask about you. I tell them you're resting, at the hospital for a while. I'm sure you'll have visitors before long.

 We can go walking w/your Gerry-chair every time I come, if you like.

 There's a room I saw down there, with flowers and a piano and lots of light. I'll investigate. Maybe you can visit there, too.

Found in *A Farewell to Arms* by Ernest Hemingway.
Published by Charles Scribner's Sons, 1969.

Dearest Dad,

It's June 19, 1994,

Father's Day.

I am so glad you can get some rest, now! These people are so good at what they do, and they know how to care for you.

I hope you will be able to get a bit better so we can still have good times, + make plans together.

Everyone asks about you and says to give you their greetings. Many are remembering you also in prayer.

It is very hot out today. In here it is cool and pleasant.

The flowers ~ the little basket are from Peg ~ ...
always love...

Hi! It's June 21st! You are really sleepy, but you smiled at me tonight. I came later, so that you might be awake. And you were! [sort of]

It's been cloudy today, off + on, + breezy. Storms threaten, but don't emerge.

Sue has been visiting. She brought me a "personal pizza" + bread sticks for supper. [You + I] → We went for a walk! That's a first! I'll have the TV turned on tomorrow. I'm so glad you're getting rested. People ask about you. I tell them you're resting, at the hospital for a while. I'm sure you'll have visitors before long.

We can go walking w/ your Gorry-chair every time I come, if you like.

There's a room I saw down there, with flowers and a piano and lots of light. I'll investigate. Maybe we can visit there, too.

Fall

Fall

1. I don't. Fall is a very pleasant
2. season because it rains so we
3. cannot go to school and it begins
4. to snow a little in the fall.
5. In the fall they gather all
6. most all the vegetable such
7. as potatoes, turnips, beats,
8. apples and carrots. Some folks
9. thinks that fall is the most
10. pleasantest part of the year.
11. Because all the leaves drop
12. from the tree and they gath-
13. er them up and press the
14. leaves in a book and then
15. in the winter they make
16. wreaths, crosses and anchors out
17. of the leaves and hang them
18. around the wall and pict-
19. ures which makes the
20. room look very pretty. I
21. guess I will come to a close
22. for I have written my 23
23. lines. Jennie E. Smallidge

Found in *The Old Curiosity Shop* by Charles
Dickens. Published by Porter and Coates, 1893.

Fall.

1. I dont fall is a very pleasant
2. season because it rains so we
3. cannot go to school and it begins
4. to snow a little in the fall.
5. In the fall they gather all
6. most all the vegetable such
7. as potatoes, turnips, beats,
8. apples and carrots. Some folks
9. thinks that fall is the most
10. pleasantest part of the year.
11. Because all the leaves drop
12. from the tree and they gath-
13. er them up and press the
14. leaves in a book and then
15. in the winter they make
16. wreaths, crosses and anchors out
17. of the leaves and hang them
18. around the wall and pict-
19. ures which makes the
20. room look very pretty. I
21. guess I will come to a close
22. for I have written my 25-
23. lines. Jennie E Smallidge

Gain a Little Every Day

A POEM:

Gain a Little Every Day

1. Gain a little useful knowledge
Every day my boy.
Search for secrets that are hidden,
In your tool or toy;
Do not shrink from when and wherefore,
How and which and why—
They are helpers to prepare you
For the by-and-by

2. By-and-by, when to your labor
You go forth—a man,
And the goal you seek seems saying,
"Gain me in you can!"
A good acorn holds an oak tree:
So success may find
Its beginning in the riches
Of a well-stored mind

WRITTEN UPSIDE DOWN:

Homer S. Lake
Phelps
Ont. Co.
New York

Thanksgiving
Nov. 28, 1900

Gain a little every day

1. Gain a little useful knowledge
 Every day my boy
 Search for secrets that are
 hidden
 In your tool or toy;
 Do not shrink from when
 and wherefore,
 How and which and why—
 They are helpers to prepare
 you
 For the by-and-by.

2. By-and-by, when
 You go forth—a tree;
 And the goal you
 seems saying,
 "Gain me if

A good acorn holds an oak
So success may find
To beginning in the riches
Of a well-stored mind.

Found in *The Lost Years: A Biographical Fantasy* by Oscar Lewis. Published by Alfred A. Knopf, 1951.

FORGOTTEN BOOKMARKS [91]

The Pledge

Pledge

We the undersigned solemnly promise God being our helper to abstain from the use of intoxicating liquors as a beverage.

> John P. Bugden
> Frank E. Bugden
> Nellie L. Bugden
> M. Clara Bugden

Found in *The White House Cook Book* by Mrs. F. L. Gillette. Published by L. P. Miller, 1890.

Black List

A "BLACK LIST" OF NAMES,
WITH NOTATION AT THE TOP:

by JC Merritt, Marlboro, prob.
between 1876–1900

Found in *Jane Eyre* by Charlotte Brontë. Published by Donohue and Henneberry, no date, circa 1900.

Inflation

A NOTE:

Found in *Zen and the Art of Motorcycle Maintenance* by Robert M. Pirsig. Published by William Morrow and Company, 1974.

He Trusteth in Thee

A BIBLE VERSE WRITTEN ON A TRIMMED AND FLATTENED PIECE OF BIRCH BARK:

Thou wilt keep
him in perfect
peace whose mind
is stayed on thee
because he trusteth in thee.

Is. 26:3

Found in the Holy Bible.
Published by the American
Bible Society, 1879.

The Firm

A MEMO TO EMPLOYEES OF BRESEE'S DEPARTMENT STORE IN ONEONTA, NEW YORK:

ATTENTION STORE EMPLOYEES...

Saturday at 1:30pm you will be permitted to leave the store and see the Parade. At this time the Store will be closed until 3:15, However you are requested to ring back in at 3:10 and be in your departments ready to serve the customers at 3:15 sharp. All lunch periods will begin at 1:30 and end at 3:10! There will be no Health Bar or Rest periods throughout the day.

Everyone must enter the store by the way of Wall Street so as not to block up the Main Street entrance.

the Firm

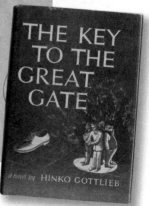

Found in *The Key to the Great Gate* by Hinko Gottlieb.
Published by Simon and Schuster, 1947.

Cassie's Coming Back

THIS APPEARS TO BE AN EMPLOYEE'S LIST OF COMPLAINTS TO HER BOSS:

11/19/02

After consistently working 52 hours 48 43 @ the least . . .

hrs get cut to 40 no overtime.

Cassie's coming back . . .

"black ass" comment

"coon hunting"

Found in *The Blind Assassin* by
Margaret Atwood. Published by
Anchor Books, 2001.

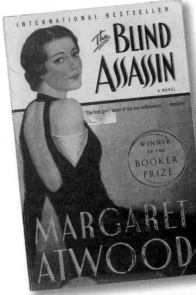

So Mean

A NOTE:

Fri A.M.

Dear Eleanor,

Why do you have to be so mean to me?
 That night when I came up you acted swell,
but since then, _____

Found in *Nine Days to Mukalla* by
Frederic Prokosch. Published by
Viking Press, 1953.

Please Feed Me

A NOTE:

Please feed me!
But why?
Feed me now!!
Stupid jerk!
May the gods let you rot.
Kira please feed me!
I am very extremely hungry!

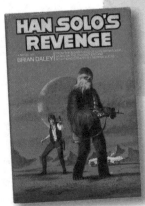

Found in *Han Solo's Revenge* by Brian
Daley. Published by Del Rey, 1979.

Summer Flowers

A NOTE:

Dear Mary & Joe

Your summer flowers and arrangements have been beautiful, helping to make the summer heat forgiveable.

> With our thanks,
> Mary & Dick 8/2/88

Found in *The Education of a Gardener* by Russell Page. Published by Vintage Books, 1985.

A Prayer for My Daughter

A PRINTED COPY OF WILLIAM BUTLER YEATS'S POEM:

A Prayer for My Daughter

Once more the storm is howling, and half hid
Under this cradle-hood and coverlid
My child sleeps on. There is no obstacle
But Gregory's wood and one bare hill
Whereby the haystack- and roof-levelling wind,
Bred on the Atlantic, can be stayed;
And for an hour I have walked and prayed
Because of the great gloom that is in my mind.

I have walked and prayed for this young child an hour
And heard the sea-wind scream upon the tower,
And under the arches of the bridge, and scream
In the elms above the flooded stream;
Imagining in excited reverie
That the future years had come,
Dancing to a frenzied drum,
Out of the murderous innocence of the sea.

May she be granted beauty and yet not
Beauty to make a stranger's eye distraught,
Or hers before a looking-glass, for such,
Being made beautiful overmuch,
Consider beauty a sufficient end,
Lose natural kindness and maybe
The heart-revealing intimacy
That chooses right, and never find a friend.

Helen being chosen found life flat and dull
And later had much trouble from a fool,
While that great Queen, that rose out of the spray,
Being fatherless could have her way
Yet chose a bandy-legged smith for man.
It's certain that fine women eat
A crazy salad with their meat
Whereby the Horn of Plenty is undone.

In courtesy I'd have her chiefly learned;
Hearts are not had as a gift but hearts are earned
By those that are not entirely beautiful;
Yet many, that have played the fool
For beauty's very self, has charm made wise,
And many a poor man that has roved,
Loved and thought himself beloved,
From a glad kindness cannot take his eyes.

May she become a flourishing hidden tree
That all her thoughts may like the linnet be,
And have no business but dispensing round
Their magnanimities of sound,
Nor but in merriment begin a chase,

Nor but in merriment a quarrel.
O may she live like some green laurel
Rooted in one dear perpetual place.

My mind, because the minds that I have loved,
The sort of beauty that I have approved,
Prosper but little, has dried up of late,
Yet knows that to be choked with hate
May well be of all evil chances chief.
If there's no hatred in a mind
Assault and battery of the wind
Can never tear the linnet from the leaf.

An intellectual hatred is the worst,
So let her think opinions are accursed.
Have I not seen the loveliest woman born
Out of the mouth of Plenty's horn,
Because of her opinionated mind
Barter that horn and every good
By quiet natures understood
For an old bellows full of angry wind?

Considering that, all hatred driven hence,
The soul recovers radical innocence
And learns at last that it is self-delighting,
Self-appeasing, self-affrighting,
And that its own sweet will is Heaven's will;
She can, though every face should scowl
And every windy quarter howl
Or every bellows burst, be happy still.

And may her bridegroom bring her to a house
Where all's accustomed, ceremonious;
For arrogance and hatred are the wares
Peddled in the thoroughfares.
How but in custom and in ceremony
Are innocence and beauty born?
Ceremony's a name for the rich horn,
And custom for the spreading laurel tree.

—William Butler Yeats, 1921

"Cutting casts an eye on the emotional pains behind
a dark adolescent practice."
—Salon

Cutting

Understanding
and Overcoming
Self-Mutilation

STEVEN LEVENKRON
Author of Anatomy of Anorexia

Found in *Cutting: Understanding and Overcoming Self-Mutilation* by Steven Levenkron. Published by W. W. Norton, 1998.

A Prayer for My Daughter

Once more the storm is howling, and half hid
Under this cradle-hood and coverlid
My child sleeps on. There is no obstacle
But Gregory's wood and one bare hill
Whereby the haystack- and roof-levelling wind,
Bred on the Atlantic, can be stayed;
And for an hour I have walked and prayed
Because of the great gloom that is in my mind.

I have walked and prayed for this young child an hour
And heard the sea-wind scream upon the tower,
And under the arches of the bridge, and scream
In the elms above the flooded stream;
Imagining in excited reverie
That the future years had come,
Dancing to a frenzied drum,
Out of the murderous innocence of the sea.

May she be granted beauty and yet not
Beauty to make a stranger's eye distraught,
Or hers before a looking-glass, for such,
Being made beautiful overmuch,
Consider beauty a sufficient end,
Lose natural kindness and maybe
The heart-revealing intimacy
That chooses right, and never find a friend.

Helen being chosen found life flat and dull
And later had much trouble from a fool,
While that great Queen, that rose out of the spray,
Being fatherless could have her way
Yet chose a bandy-legged smith for man.
It's certain that fine women eat
A crazy salad with their meat
Whereby the Horn of Plenty is undone.

In courtesy I'd have her chiefly learned;
Hearts are not had as a gift but hearts are earned
By those that are not entirely beautiful;
Yet many, that have played the fool
For beauty's very self, has charm made wise,
And many a poor man that has roved,
Loved and thought himself beloved,
From a glad kindness cannot take his eyes.

May she become a flourishing hidden tree
That all her thoughts may like the linnet be,
And have no business but dispensing round
Their magnanimities of sound,
Nor but in merriment begin a chase,
Nor but in merriment a quarrel.
O may she live like some green laurel
Rooted in one dear perpetual place.

My mind, because the minds that I have loved,
The sort of beauty that I have approved,
Prosper but little, has dried up of late,
Yet knows that to be choked with hate
May well be of all evil chances chief.
If there's no hatred in a mind
Assault and battery of the wind
Can never tear the linnet from the leaf.

An intellectual hatred is the worst,
So let her think opinions are accursed.
Have I not seen the loveliest woman born
Out of the mouth of Plenty's horn,
Because of her opinionated mind
Barter that horn and every good
By quiet natures understood
For an old bellows full of angry wind?

Considering that, all hatred driven hence,
The soul recovers radical innocence
And learns at last that it is self-delighting,
Self-appeasing, self-affrighting,
And that its own sweet will is Heaven's will;
She can, though every face should scowl
And every windy quarter howl
Or every bellows burst, be happy still.

And may her bridegroom bring her to a house
Where all's accustomed, ceremonious;
For arrogance and hatred are the wares
Peddled in the thoroughfares.
How but in custom and in ceremony
Are innocence and beauty born?
Ceremony's a name for the rich horn,
And custom for the spreading laurel tree.

—WILLIAM BUTLER YEATS, 1921

Walking in Dreams

A POEM, DATED SEPTEMBER 14, 1975:

Walking in dreams,
I shift my back
to split the sky,
and wind throws
a shadow,
freezing fast.

You speak, tide-tongued,
of the salt-lipped shore
as a gull glides wide
to break the air.

Silence blows on a cloud
to draw in the sea
and clap its waves
against a riddled coast.

Alone, I piece my flesh
amongst the tangled shells,
and cast my thoughts
before you move.

Thank you for a sun-drenched day.

—*cia*

Found in *The Awful Rowing Toward God* by Anne Sexton. Published by Houghton Mifflin, 1975.

Alone, I piece my flesh
amongst the tangled shells,
and cast my thoughts
before you move.

9.14.75

Walking in dreams,
I shift my back
to split the sky,
and wind throws
a shadow,
freezing fast.

You speak, tide-tongued,
of the salt-lipped shore
as a gull glides wide
to break the air.

Silence blows on a cloud
to draw in the sea
and clap its waves
against a riddled coast.

Thank you for
a sun-drenched day.
—cia

How to Be Good

How to Be Good

Dialogue for the children

(All) We children three, a happy band,
Before our friends assembled stand,
To thank our Father for this sight,
And for the pleasant Christmas night.

(Walter) I am the oldest, as you see,
And I must an example be;
Must strive to do the things I'm told,
And for the truth be firm and bold.
In patience, I must bear with brother,
Teach him to love and care for Mother;
Be friend to little sister here,
And love and pray for Father dear.
And I must pray to Jesus too,
To cleanse my heart and make it new.
That I may love him while I love.
And when I die, a crown receive.

(Eugene) _____

(Jennie) I am a very little child,
And sometimes I am very wild;
I do not do the things I'm taught,
Nor love the savior as I ought.
But I will ask him when I pray,
To take my naughty thoughts away,

And make loving, good & mild
And fit to be his holy child.

(All) Father in Heaven our hearts
keep pure,
Preserve us from all sin,
And save us all in heaven above
For Jesus' sake—Amen.

(Jennie) I am a very little child,
And sometimes I am very wild;
I do not do the things I'm taught.
Now love the savior as I ought.
But I will ask him when I pray,
To take my naughty thoughts away,
And make loving good & mild
And fit to be his holy child.

(All) Father in Heaven our hearts
keep pure,
Preserve us from all sin,
And save us all in heaven above
For Jesus' sake — Amen.

"Trying to be Good."
...gue for them Children
(All) We children here, a happy band,
Before our friends assembled stand,
To thank our Father for this sight,
And for the pleasant Christmas night.

(Walter) I am the oldest, as you see,
And I must an example be;
Must strive to do the things I'm told,
And for the truth be firm and bold.
In patience, I must bear with brother,
Teach him to love and care for mother,
Be kind to little sister here,
And love and pray for Father, dear,
And I must pray to Jesus too,
To cleanse my heart and make it new.
That I may love him while I live,
And when I die, a crown receive,
(Eugene)

Found in *Our Girls: Stories and Rhymes for Home, School and Kindergarten*.
No author listed. Published by the Saalfield Company, 1901.

James H. Gano

A PIECE OF HEAVY PARCHMENT, TORN AT THE BOTTOM:

This certifies that James H. Gano has this day appeared before me armed and equipped as required by law and enlisted into a company of Light Infantry under my command.

> *Plainfield Sept 13 1833*
> *Dean Burgess, Capt*

Found in *The American Museum, or Repository of Ancient and Modern Fugitive Pieces, Prose and Poetical*, edited by Mathew Carey. Published by the editor, 1788.

You will be relieved to discover that Mr. James H. Gano, who was born in 1814, died many years later in 1904. I couldn't find much information about Mr. Burgess, unless the following passage from the Connecticut Genealogy site refers to him:

Military matters excited some attention. In 1799 the town voted to exempt from certain taxation all non-commissioned officers, musicians and privates who should equip themselves as to arms, clothing and accoutrements, and do military duty. Abel Andrus was at this time lieutenant colonel of the Twenty-first Regiment; Shubael Hutchins, first major; Reverend Joel Benedict, chaplain; Sessions Lester, quartermaster: George Middleton, paymaster; Doctor Johnson, of Westminster, surgeon; Daniel Gordon, surgeon's mate; Frederick Andrus, Aaron Crary, Samuel Douglas and Asa Burgess, captains of companies in the light infantry; Thomas and Daniel Wheeler and John Gordon, lieutenants and ensigns; Doctor Josiah Fuller, surgeon's mate of the cavalry regiment.

Source: "Plainfield Connecticut History 1750–1799" (www.connecticutgenealogy.com/windham/plainfield_connecticut_history_1750-1799.htm)

To My Valentine

A NOTE WRITTEN ON A PLACEMAT:

GREENE'S GRILL
13 GROTON AVE.
BEST IN FOODS
PHONE 208

WRITTEN ON THE BACK:

To My Valentine!!!

I ain't so good at sayin' things,
I ain't so good in art,
But if you accept this valentine,
Then you accept my heart.

"Ted"

Found in *The New Wonder Book of Knowledge*, compiled and arranged by Henry Chase Hill. Published by the John C. Winston Company, 1936.

King Richard

A POLITICAL PROTEST ANNOUNCEMENT,
MOST LIKELY FROM 1973 OR 1974:

HEAR YE! HEAR YE!

People of SUCO, and all other people who value their Liberty!
A rally will be held on Monday, February 25th at
8:00 P.M. in the College Union Ballroom. The purpose of this
rally is to DETHRONE KING RICHARD NIXON!!!
Our land is once again afoul with Tories who would
keep the people in chains in order to increase their profits
at the expense of our liberties. King Richard is but the
monarch (and somewhat of a figurehead at that) at the head
of this Corporate Dictatorship. The Peoples Bicentennial
Commission recognizes that there is more to securing our
freedoms than simply getting rid of King Richard. He is
but the top of the "iceberg of despotism" that is freezing
our liberties. Yet, we also realize that it is important
for all freedom-loving patriots- the new sons and daughters
of Liberty- to have a point to rally around. The first
American Revolution was more than a blow to King George!!!
The second American Revolution will be a victory—ever of
the common folks over the corporate monopolies and their
political conspirators (Richard Nixon, to name one of them).
Therefore, be it resolved that...
THE REMOVAL OF KING RICHARD IS NECESSARY— WE MUST AGAIN
TAKE CONTROL OF OUR DESTINY!!!!!
Sponsored by the Peoples Bicentennial Commission
Representatives will speak from:
1. Vietnam Veterans Against the War/ Winter Soldier
Organization
2. National Emergency Civil Liberties Union
3. SUCO Faculty
4. Peoples Bicentennial Commission
ATTEND- HELP DETHRONE KING RICHARD!!!

Found in *The Selected Works of Thoreau:
Cambridge Edition* by Henry David Thoreau.
Published by Houghton Mifflin, 1975.

My Bookmark

I was going through one of my personal bookshelves and came across my own forgotten bookmark. This is a note for me from my dad, written around 1996 or so:

Hi Mike

GOOD DAY FOR:

- *Sealing the gutter trouble spots*
- *If painter is <u>not</u> coming, bank dirt high up wall, do all you can to divert water. There is perforated pipe under deck. Put them under the dirt first. No floods this year!*
- *Painting the back room.*

I don't remember how much I got done.

Found in *Catch 22* by Joseph Heller.
Published by Dell, 1971.

Come Out, Come Out

A LIST OF SONG TITLES FROM THE FILM *STEP LIVELY*, WRITTEN ON PRODUCERS SAVINGS BANK NOTEPAPER:

Step Lively

Come Out, Come out wherever you are
Where does Love begin (and where does Friendship End)
And then you kissed me
Ask the Madame
As long as there is Music
Why Must there Be an Opening song

Found in *Ironweed* by William Kennedy.
Published by Penguin Books, 1984.

The Sins of the Flesh

The sins of the flesh imprison the minds and bodies of men.

Found in *The Intimate Henry Miller* by Henry Miller. Published by Signet, 1959.

Spackle

A SHOPPING LIST:

White ceiling paint
spackle for holes
clothespins
tissue
Bounty
t paper
charcoal burner
wallpaper paste

Found in *The Last Best Hope* by Peter Tauber. Published by
Harcourt Brace Jovanovich, 1977.

Today . . .

A NOTE ON PARCHMENT PAPER; LOOKS
TO BE PRINTED RATHER THAN WRITTEN:

Found in *Sex Without Guilt* by Albert Ellis,
PhD. Published by Lyle Stuart, 1958.

Held My Ground

A NOTE THAT LOOKS LIKE IT MIGHT HAVE BEEN TORN FROM A JOURNAL:

1/7/97

Went to work

Boss was told by someone about being arested, almost relaps into doing drugs!

But held my ground after talking to mom, Doren, Fred

Feel a little bit better

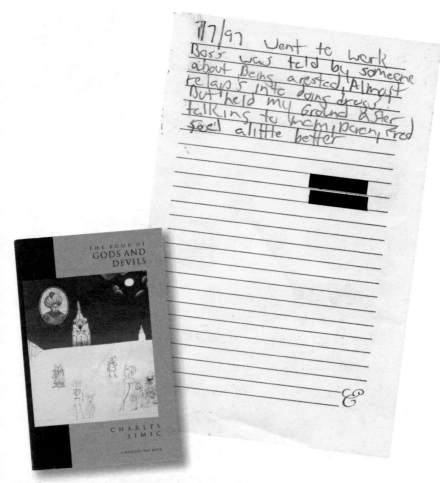

Found in *The Book of Gods and Devils* by Charles Simic.
Published by Harcourt Brace Jovanovich, 1990.

Receipts, Invoices, Advertising, and Other Official Documents

Receipts

Received, Schoharie, Blenheim April 6th 1805 from Mr. George Martin—Twenty three Dollars, and Ninety Cents, in full of Book Account.

 23 dols. 90 Cts.

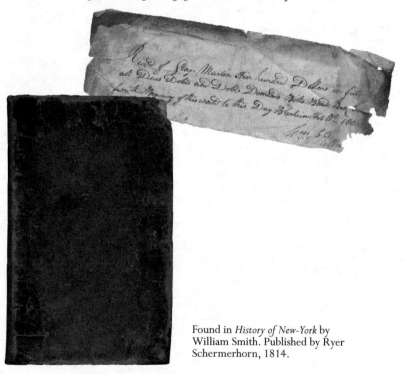

Record of George Martin Five hundred dollars in full of all dues debts and debts demands bills bonds book and from the beginning of this world to this day Blenheim Feb. 8th 1804.

Found in *History of New-York* by William Smith. Published by Ryer Schermerhorn, 1814.

Way Back When

"Way Back When"

"Way back when" it was twelve days from Washington to New Orleans by the old wood-burning engine and the stage:—Today, it's less than twelve hours by the modern mail plane. *Science pointed the way.*

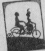

"Way back when" labor was by hand work with crude tools:—Today machines are perfected to almost unbelievable tasks; the forces of nature harnessed to startling results:— *Science put on the speed.*

Now, only man's appetite for strong drink harks back to "Way Back When," for now *science proves that beverage alcohol has no place in this modern age.*

Volume One of the American Almanac, dated way back in 1830 says,—after quoting at length on the evils of that day resulting from the liquor traffic:

"There is nothing then to counterbalance the evils produced by the abuse of ardent spirits. . . . there is no good reason why they should not be banished entirely from common use. The only way to avoid the ABUSE is to get rid of the USE, to get rid of them, in short, altogether."

In 1830 Science *Suggested* Abstinence
In 1931 Science *Demands* Abstinence

"You can get along with a wooden leg, but you can't get along with a wooden head It's the brain that counts and in order that your brain may be kept clear, you must keep your body fit and well."

DR. CHARLES MAYO.

use) or the frequent-ing of places where they are sold is sufficient cause for dismissal."

Now, even the "wettest of the wets" would scoff at the very idea of a railroad engineer who is not an abstainer.

Speed—Efficiency—Competition of Crack Trains Demands Sobriety

Would the "wettest of the wets" trust himself *in an airplane with a pilot who had had even one drink?*

Beverage alcohol has no place in this modern age

Price 2 cents; 25 cents per 50; 45 cents per 100
SIGNAL PRESS
Evanston, Illinois

Found in *The Party Battles of the Jackson Period* by Claude G. Bowers. Published by Houghton Mifflin, 1928.

Beer Labels

AN ENVELOPE FROM THE LION BREWERY, 1905.

INSIDE ARE FOUR BEER LABELS, ALL FROM THE PILSER BEER FAMILY: DANBORG BEER, PARAMOUNT BEER, MALTCREST BREW, AND A LABEL FROM A HALF BARREL OF PILSER'S LIGHT BEER.

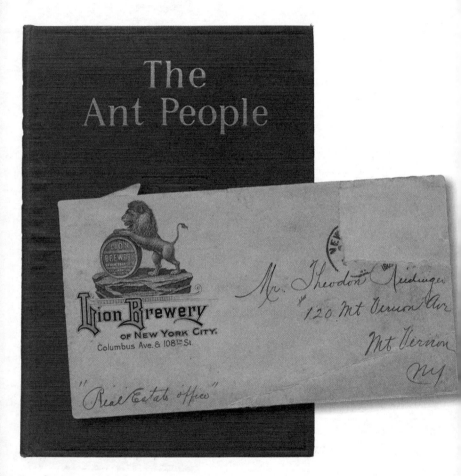

Found in *The Ant People* by Hanns Heinz Ewers.
Published by Dodd, Mead, and Company, 1937.

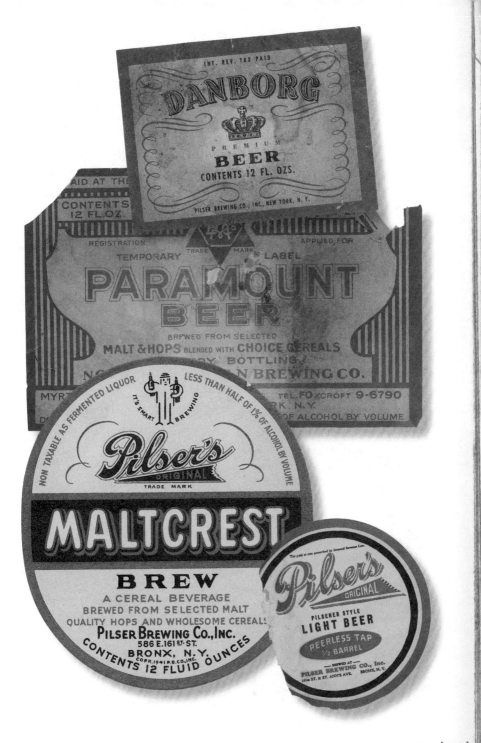

Greene County

A RECEIPT FROM THE GREENE COUNTY, NEW YORK, UNITED REPUBLICAN FINANCE COMMITTEE, DATED SEPTEMBER 25, 1936, IN THE AMOUNT OF ONE DOLLAR:

Found in *The American Claimant* by Mark Twain. Published by Charles L. Webster and Company, 1892.

Dr. Sheldon's Sanitarium

AN ADVERTISING CARD:

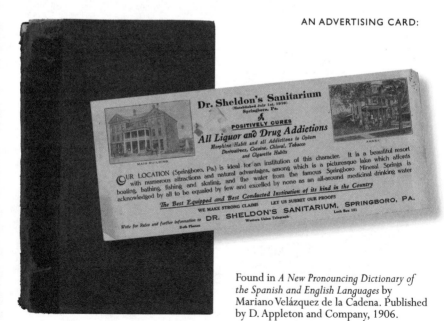

Found in *A New Pronouncing Dictionary of the Spanish and English Languages* by Mariano Velázquez de la Cadena. Published by D. Appleton and Company, 1906.

Harry J. Butts

A TORN INVOICE:

Oneonta, NY—Jan 15 1934

M.A. Ross

in account with

> Harry J. Butts
> *Freight and Baggage Transfer*
> *Guaranteed Service on Freight Shipment*
> *High-Grade Coal a Specialty*

Found in *The Making of Illinois* by
Irwin F. Mather. Published by A.
Flanagan Company, 1911.

Corsets

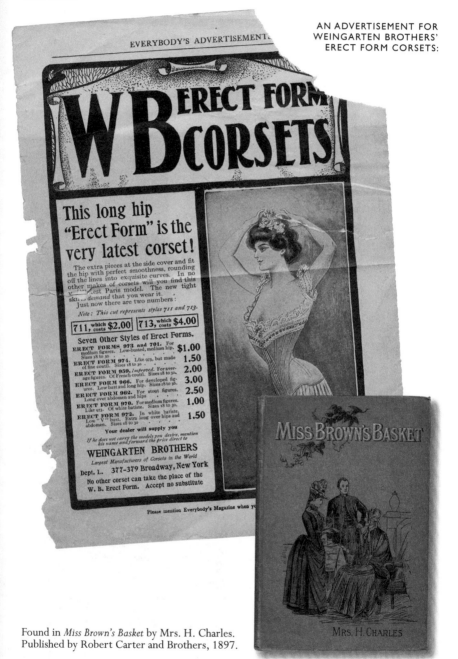

Found in *Miss Brown's Basket* by Mrs. H. Charles.
Published by Robert Carter and Brothers, 1897.

E. B. Estes Company

A REMOVAL NOTICE ANNOUNCING BOTH THE SEVENTIETH ANNIVERSARY AND
MOVING OF THE OFFICES OF THE E. B. ESTES COMPANY, DATED 1917:

1847–1917—Telephone Greeley 4820-4821

New York, January 18th, 1917.

E.B. Estes and Sons, on this seventieth anniversary of their establishment, announce the removal of their New York offices, sales and sample rooms to 362 & 364 Fifth Avenue, near 34th Street, New York.

At this new centrally located address, convenient to the railroad terminals and the hotel center, they hope to have the pleasure of your frequent visits.

Warehouse, Bush Terminal Building No. 10, Brooklyn NY

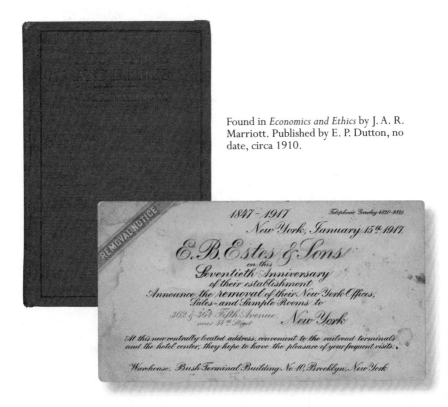

Found in *Economics and Ethics* by J. A. R.
Marriott. Published by E. P. Dutton, no
date, circa 1910.

Diploma

A DIPLOMA, DATED JANUARY 1936:

Cross Crown
Diploma for Attendance

This certifies that Lois French has fulfilled all the requirements of regular attendance in our school and merits the Official Gold Badge for having complete four terms of three months each ending January, 1936.

Evangelical Lutheran (school)
Poestenkill (town or city)

Mrs. Philip Fisher (superintendent)
New York (state)

Found in *Sam Loyd's Cyclopedia of 5000 Puzzles Tricks and Conundrums with Answers* by Sam Loyd. Published by Morningside Press, 1914.

Bridge Tally

A SCORING TALLY FOR BRIDGE:

Standard Auction Bridge

VALUES	♣	♦	♥	♠	No Trp
Each Trick	6	7	8	9	10
Three Honors	30	30	30	30	30
Four Honors	40	40	40	40	40
Five Honors	50	50	50	50	
Four Honors (in One Hand)	80	80	80	80	100
Five Honors (4 in One Hand) (4th in Partner's)	90	90	90	90	
Five Honors (in One Hand)	100	100	100	100	

Game 30 Points. Rubber 250 Honors
Small Slam 50 Honors. Grand Slam 100 Honors

Contract Bridge

CONTRACT BRIDGE	♣	♦	♥	♠	No Trp
Each trick over six	20	20	30	30	35
4 in one hand	100	100	100	100	150
5 in one hand	150	150	150	150	

BONUSES

	Not vulnerable		Vulnerable		
	Undoubled	Doubled	Un-doubled	Doubled	
Contract....		0	50	0	100
Each extra trick	50	100		50	200

A redouble, doubles the doubled value.

AGGREGATE PENALTIES

	Not vulnerable		Vulnerable	
	Undoubled	Doubled	Undoubled	Doubled
1 down.....	50	100	100	200
2 "	100	200	300	600
3 "	150	400	500	1000
4 "	200	600	700	1400
5 "	250	1000	900	1800
Each additional				
trick	50	400	200	400

First revoke : 2 tricks.
Additional revoke : 100 honors.
Game - 100 points, bid and made — Premium final 500.
Game - 2 game rubber 700 — 3 game rubber 500.
Little Slam, bid and made : 500 when not vulner.
750 when vulnerable.
Big Slam, bid and made : 1000 when not vulner.
1500 when vulnerable.
No bonus for slam made but not bid.
Doubling does not increase bonus for slam.

NAME	DATE

Yes, you can still smell it.

Found in *T. S. Eliot: Selected Prose* by T. S. Eliot. Published by Penguin Books, 1953.

Contract

A CONTRACT AGREEING TO THE
MANUFACTURE OF PRUNING SHEARS, DATED 1871:

CONTRACT.

WHEREAS, LAWRENCE CAMPBELL, of Marengo, county of Calhoun, State of Michigan, did obtain Letters Patent of the United States, for certain IMPROVEMENTS IN PRUNING AND HEDGE SHEARS, which Letters bear date the 22d of September, 1868, and are numbered 82,290;

Now this Agreement Witnesseth, that JOHN SWEENEY, of Quincy, Michigan, hereby agrees to manufacture and furnish to _E. H. Robbins_ said Pruning and Hedge Shears, for the price and sum of TWO DOLLARS AND FIFTY CENTS, each, for the small size, and THREE DOLLARS, each, for the large size, on delivery, during the life of said Patent.

And the said _E. H. Robbins_ agrees to pay to the said John Sweeney, Two Dollars and Fifty Cents, each, for the small size, and Three Dollars, each, for the large size, payable on delivery for all Shears ordered.

Said Shears to be delivered at the Express Office named in the order.

P.O. _Quincy Mich_ _John Sweeney_
Dated Nov 7th 1871

Found in _Jewels for the Household; or Selections of Thought and Anecdote for Family Reading_ by Tryon Edwards. Published by Case, Lockwood, and Company, 1858.

Indy 500

A TICKET FOR ADMITTANCE TO THE PAGODA AREA AND OBSERVATION DECK OF THE INDIANAPOLIS MOTOR SPEEDWAY. THE TICKET WAS GOOD FOR TIME TRIALS ONLY, MAY 1954:

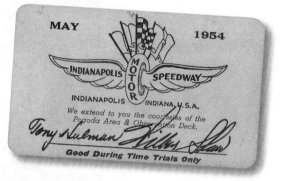

The bottom of the card has signatures from Tony Hulman and Wilbur Shaw.

Hulman purchased the Indianapolis Motor Speedway in 1945 and is credited to making the Indianapolis 500 an American sporting classic.

Shaw was a driver and won the Indianapolis 500 in 1937, 1939, and 1940. Hulman purchased the track at the urging of Shaw and was rewarded by being named president.

Shaw died in a plane crash on October 30, 1954.

Found in *Walden* by Henry David Thoreau. Published by Peter Pauper Press, 1966.

Two Dollars

A TWO-DOLLAR BILL FROM 1976:

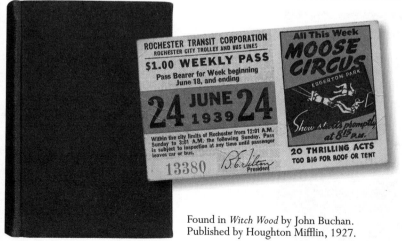

Found in *Frankenstein* by Mary Shelley.
Published by Penguin Classics, 1985.

Moose Circus

A TRANSIT PASS FOR THE CITY OF ROCHESTER, NEW YORK.
GOOD FOR THE WEEK OF JUNE 24, 1939.

FEATURES AN ADVERTISEMENT
FOR THE MOOSE CIRCUS:

Found in *Witch Wood* by John Buchan.
Published by Houghton Mifflin, 1927.

Fancy Goods

A SMALL TRADE CARD:

> Nathan R. Lipe
> Books, Stationery
>
> Fancy Goods and General Variety Stock
>
> Christmas Goods A Specialty
>
> Canajoharie NY

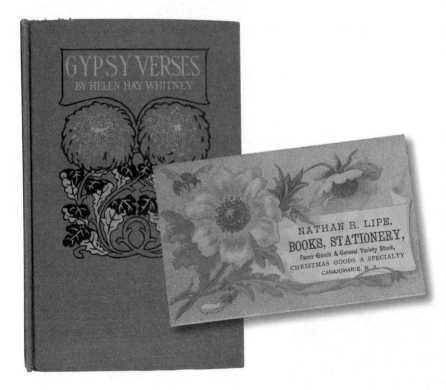

Found in *Gypsy Verses* by Helen Hay Whitney. Published by Duffield and Company, 1907.

Babies' Alumni

A CERTIFICATE ISSUED BY THE CHENANGO MEMORIAL HOSPITAL, DATED JUNE 23, 1949:

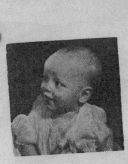

This is to certify that

David Leslie Grant

has been elected to membership in the

Babies' Alumni of Chenango Memorial Hospital

in recognition of generosity and good will to others

June 23 19 49. A. S. Wilson
 CHAIRMAN

Found in *The Captain's Chair* by Robert Flaherty.
Published by Charles Scribner's Sons, 1938.

Liquors and Lager Beer

A BUSINESS CARD:

Found in *The Illiterate Digest* by Will Rogers. Published by A. L. Burt Company, 1924.

Oxydol

A TRIMMED SIDE OF A CARDBOARD BOX OF OXYDOL DISH SOAP:

LARGE SIZE

OXYDOL

MAKES DISHES SPARKLE

How To
Entertain
At Home

...1000 *entertainment ideas*...
Compiled by the Editors of
THE MODERN PRISCILLA

Found in *How to Entertain at Home* by the editors of the *Modern Priscilla*. Published by the Priscilla Publishing Company, 1927.

Military Training Commission

THE CHILDREN
EDITH WHARTON

A CERTIFICATION CARD FOR THE NEW YORK MILITARY TRAINING COMMISSION, DATED 1918:

11-15-18-300,000 (48-815)

**STATE OF NEW YORK
MILITARY TRAINING COMMISSION**

NOT TRANSFERABLE

This Certifies that the bearer whose signature appears on the line following:

Name _____

Address _____ , State of New York, is enrolled for military training as a member of the Corps of Cadets, State of New York, in conformity with the provisions of the Military Law of the State, and is meeting the requirements of the law as to such military training.

W.K. Whitley
1st L'eut., R.L.

Subject to cancellation by the Military Training Commission.

Zone Supervising Officer, Military Training

By _____

Not valid after December 31, 1918, unless endorsed as indicated on back hereof

Found in *The Children* by Edith Wharton. Published by D. Appleton and Company, 1928.

H. A. Plumb

A TOP PORTION OF A CALENDAR ADVERTISING H. A. PLUMB OF UTICA, NEW YORK.
THERE IS A COPYRIGHT OF 1909, CLARENCE BALL, IN THE LOWER RIGHT CORNER;
NO OTHER DATES SHOWN:

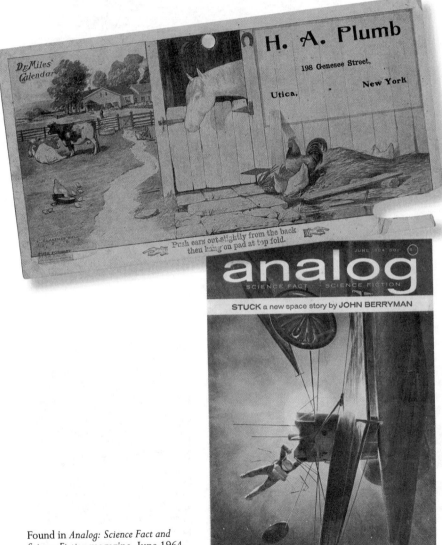

Found in *Analog: Science Fact and Science Fiction* magazine, June 1964.

The Ghost Story

AN ILLUSTRATED TRADE CARD:

THE moral of this, the Sixteenth Card of our Series, is that, young ladies would avoid creating a scene, similar to **The Ghost Story !** the one the artist, Mr. R. W. Buss, gives us in this admirable picture, they had better forego reading ghost stories at bed-time.

As the rough, wintry season of the year approaches, do not for a . . . a **Cold**, once contracted, demands . . . mpt treatment, lest the accompanying Cough should hasten . . . ack the Lungs, and induce the formation of tuecrcles. By L . . . of **Dr. Jayne's EXPE . . . DRANT**, in small doses,—repeating sam . . . according to the urgen . . . of the symptoms,—your Cold will speedily yield, or your Lungs . . . scape a dangerous ordeal. If you should be seized with a **Sore Throat, Bronchitis**, or any **Bronchial Disorder**, the **EXPECTORANT** will subdue the inflammation of t . . . parts, detach the mucous matter which clogs them, and gradually promote a cure. In case of **Asthma**, the **EXPECTORANT** overcomes the cause of the trouble, and a prompt restoration follows. If attacked by **Pleurisy**, or any **Acute Inflammation** of the Lungs or Throat, take the **EXPECTORANT** according to directions,—bathing the parts thoroughly with **DR. JAYNE'S LINIMENT**,—and covering up warmly in bed. The **EXPECTORANT**, if taken in quite small doses by **Consumptives**, will ameliorate the symptoms, and especially ease the Cough as well as the oppression and soreness of the Lungs and Throat. It is a helpful remedy also in cases of **Croup** and **Whooping-Cough**, checking the violence of the attacks, and relieving the attending distress.

A Trusty Family Tonic is at the service of those possessing a bottle of **DR. JAYNE'S TONIC VERMIFUGE**. For the **Dyspepsia of Adults**, Indigestion, Sour Stomach, Oppression at the pit of the Stomach, and Low Spirits, it is an excellent remedy,—the bowels in such cases being kept open, when necessary, by **DR. JAYNE'S SANATIVE PILLS**. **Worms in Children** it destroys with certainty, removing them and the distressing symptoms to which they give rise. As a **Strengthening Tonic** for feeble, sickly children, it renews the appetite and rebuilds the general health, and it has a curative effect in the Fever and Ague of the young.

PRESENTED BY

CHAS. A. WOODWORTH,
Lodi, Seneca Co.,
New York.

THE MAJOR & KNAPP LITH. CO. N.Y.

THE REVERSE TOUTS THE WONDERFUL CURATIVE POWERS OF DR. JAYNE'S TONICS AND PILLS:

Found in *Poems of Shelley* by Percy Bysshe Shelley. Published by Macmillan, 1887.

Report Card

A REPORT CARD FOR STUDENT JENNIE SMALLIDGE, DATED FALL 1874:

NEWARK UNION SCHOOL.
1st INTERMEDIATE DEPARTMENT.

Jennie Smallidge
For *Fall* Term, 187—

						Deportment	Reading	Spelling	Grammar	Geography	Arithmetic	Intellectual Arithmetic	Writing	Drawing	Map Drawing	Examination	Literary Exercises		Demerit Marks	SIGNATURE OF PARENT.
FIRST WEEK,						9.5	10	10		10	9.5	10								
SECOND WEEK,						10	10	10		10	9.5	10								Mrs M Smallidge
THIRD WEEK,		1				10	10	9.6		10	10	10								Mrs M Smallidge
FOURTH WEEK,						9.5	10	10		9.6	10	10			8.75					Mrs M Smallidge
FIFTH WEEK,		1				6	10	10		9.5	10	9.5								Mrs M Smallidge
SIXTH WEEK,						9.5	10	10		9.6	9.5	9.6			9.58					Mrs M Smallidge
SEVENTH WEEK,						8	10	10		10	9.6	10								Mrs M Smallidge
EIGHTH WEEK,						10	10	10		10	9.5	10			10					Mrs M Smallidge
NINTH WEEK,						9.5	10	10		8.5	10	10								Mrs M Smallidge
TENTH WEEK,																				
ELEVENTH WEEK,																				
TWELFTH WEEK,																				
THIRTEENTH WEEK,								1												
FOURTEENTH WEEK,						9.2	10	9.9		9.8	9.9	9.95			9.44	9.73				

Ten, our standard, indicates such perfection as is within the power of every earnest, thoughtful student. One is deducted for each failure in recitation or deportment. Demerit marks are for *gross misconduct*. The object of this Report is to inform parents of the progress of their children in their studies and deportment at school, and to furnish to parents and teachers a means of co-operation in the education of the young. Parents are earnestly requested to expect this report every Monday morning and, *after examination*, TO SIGN IT IN PERSON. Will you also encourage your children as well as us by an occasional visit to the school?

Found in *Baby Dear: A Picture Book for Little Toddlers and Their Elders*. No author listed. Published by R. Worthington, 1882.

Scouters' Club

A BOY SCOUT MEMBERSHIP CARD:

Found in *Merit Badge Series: Wildlife Management*. Published by the Boy Scouts of America, 1952.

Sox vs. Sox

TWO TICKETS FOR A BOSTON RED SOX VS.
CHICAGO WHITE SOX GAME,
JULY 22, 1988:

Boston won 4–3;

Wes Gardner got the win.

Found in *Facing the Music* by Larry Brown.
Published by Algonquin Books, 1988.

The Vault

AN ADVERTISEMENT AND INFORMATION SHEET
ON "THE AUTOMATIC SEALING BURIAL VAULT":

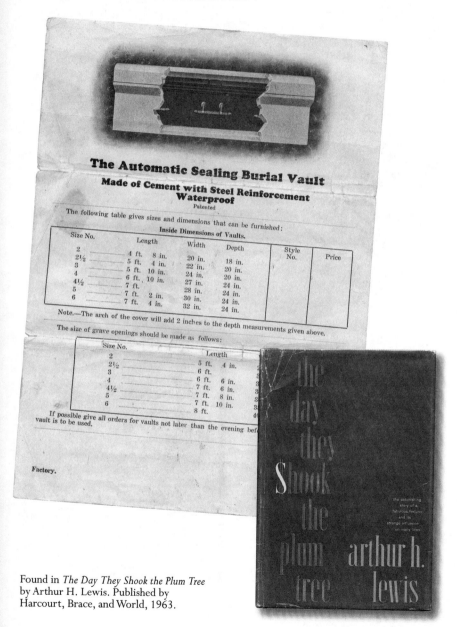

The Automatic Sealing Burial Vault
Made of Cement with Steel Reinforcement
Waterproof
Patented

The following table gives sizes and dimensions that can be furnished:

Inside Dimensions of Vaults.

Size No.	Length	Width	Depth	Style No.	Price
2	4 ft. 8 in.	20 in.	18 in.		
2½	5 ft. 4 in.	22 in.	20 in.		
3	5 ft. 10 in.	24 in.	20 in.		
4	6 ft. 10 in.	27 in.	24 in.		
4½	7 ft.	28 in.	24 in.		
5	7 ft. 2 in.	30 in.	24 in.		
6	7 ft. 4 in.	32 in.	24 in.		

Note.—The arch of the cover will add 2 inches to the depth measurements given above.

The size of grave openings should be made as follows:

Size No.	Length
2	5 ft. 4 in.
2½	6 ft.
3	6 ft. 6 in.
4	7 ft. 6 in.
4½	7 ft. 8 in.
5	7 ft. 10 in.
6	8 ft.

If possible give all orders for vaults not later than the evening before the vault is to be used.

Factory.

the
day
they
shook
the
plum
tree

the astonishing
story of a
fabulous fortune
and its
strange influence
on many lives

arthur h.
lewis

Found in *The Day They Shook the Plum Tree*
by Arthur H. Lewis. Published by
Harcourt, Brace, and World, 1963.

Oath of Importer

OATH OF IMPORTER.

PORT OF ROCHESTER,
AND DISTRICT OF GENESEE.

do solemnly and truly swear, that the Entry now delivered by me to the Collector of the District of Genesee, contains a just and true account of all the Goods, Wares and Merchandise imported by or consigned to me, in the _____ is Master, from CANADA; that the invoice which I now produce contains a just and faithful account of the actual cost of said Goods, Wares and Merchandise; that I do not know or believe in the existence of any invoice or bill of lading, other than now produced by me; and that they are in the state in which I have actually received them. And I do further solemnly and truly swear, that I have not, in the said entry or invoice, concealed or suppressed any thing, whereby the United States may be defrauded of any part of the duty lawfully due on the said Goods, Wares and Merchandise; and that if, at any time hereafter, I discover any error in the said invoice, or in the account now produced of the said Goods, Wares and Merchandise, or receive any other invoice of the same, I will immediately make the same known to the Collector of this District.

Sworn or affirmed and subscribed, this _____ day
of _____, 185__, before me,

Entry of Merchandise, imported by _____ on board the _____ _____, _____, Master, on the _____ day of _____, 1855.

Marks No.	Packages and Contents.	Whence Imported.	Foreign Value.	Dutiable Charges.	Total Amount	Rates of Duty.	Am't of Duty
2700	Bushels Wheat	Canada	5.800	146	5.946		

Found in *The History of the Decline and Fall of the Roman Empire* by Edward Gibbon. Published by Phillips, Sampson, and Company, 1851.

Worms

This celebrated Vermifuge is purely Vegetable. It has proved in all cases a safe and most certain Remedy for Worms, has a very pleasant taste and no Child will refuse to take it.

Found in *Our Family Physician* by Dr. H. R. Stout. Published by Henderson and Smith, 1885.

This celebrated Vermifuge is purely Vegetable.
It has proved in all cases a safe and most
certain Remedy for Worms, has a very
pleasant taste and no Child will refuse to
take it.

GARRIGUES' VEGETABLE

WORM CONFECTIONS

Sold by E.B. Garrigues
PHILADELPHIA.

PRICE 25 CENTS A BOX.

Directions inside KEEP DRY.

Dieses unübertreffliche Wurm Mittel ist aus rein vegetabilischen Bestandtheilen zusammengesetzt und hat sich in allen Fällen als das sicherste bekannte Mittel bewährt; vermöge seines angenehmen Geschmackes wird kein Kind sich weigern es zu nehmen.

Worms afflict all ages, from earliest infancy to advanced life, though more frequently the young. The general symptoms of Worms are a sallow complexion, with bluish circle around the eyes, and enlarged abdomen, itching at the nose & anus, headaches, nausea, foul breath, gnawing pains at the stomach and bowels, irregular appetite, bowels effected with constipation or diarrhœa, much general langour and peevishness, the sleep disturbed by frequent startings and grinding of the teeth.
These Confections, while they are powerfully specific against worms, are mild and harmless in all other cases.

Manikins

AN ADVERTISEMENT FOR TWO COMPLETE ANATOMICAL "MANIKINS":

They were given away free as part of your subscription to the *Modern Home Physician* magazine.

Found in *The Extremities* by Daniel P. Quiring, PhD. Published by Lea and Febiger, 1946.

5

The Old Curiosity Shop

From Four-Leaf Clovers to Razor Blades

Frederick

A CHILD'S DRAWING.

WRITTEN ON THE FRONT:

Farmer OCTOBER 30-1 1904

ON THE BACK:

If dark be my way
Since he is my guide
Tis mine to obey
Tis his to provide

selected
Beautiful

July 29 05
6:10 AM

From Frederick
April 16 1905
first Arbutus I had seen this spring

Found in the Holy Bible, Containing
the Old and New Testaments Translated
Out of Native Tongues. Published by
the American Bible Society, 1879.

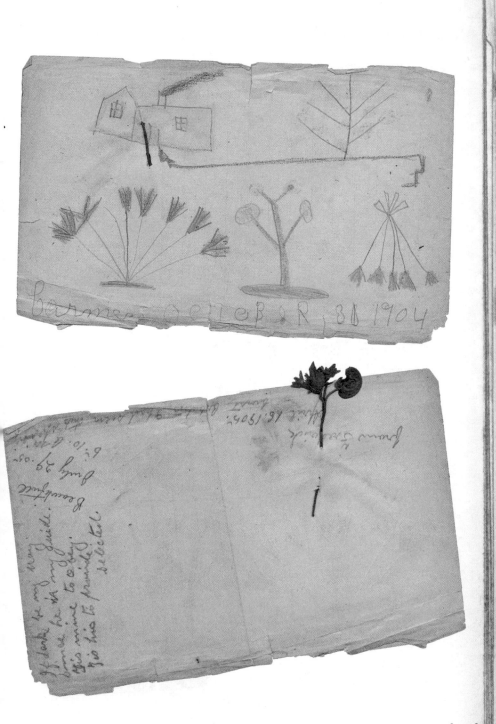

African Animals

A MAP SHOWING THE DISPERSION OF VARIOUS ANIMALS IN EASTERN AFRICA. THE MAP APPEARS TO BE HAND-DRAWN:

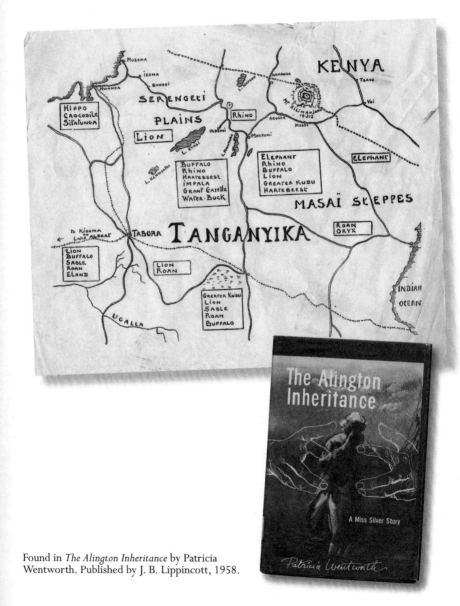

Found in *The Alington Inheritance* by Patricia Wentworth. Published by J. B. Lippincott, 1958.

James H. Curran

A SMALL ADVERTISEMENT ENDORSING JAMES H. CURRAN FOR MEMBER OF
ASSEMBLY ON THE DEMOCRATIC TICKET:

Found in *Watson's Complete Speller: Oral and Written*
by J. Madison Watson. Published by A. S. Barnes
and Company, 1880.

Music

ONE SHEET OF MUSIC, IN PENCIL:

Found in *Glee and
Chorus Book* by J. E.
NeCollins. Published
by the American Book
Company, 1911.

Applesauce

A RECIPE FOR APPLESAUCE, FOUND ON THE REVERSE SIDE OF A GRAND UNION GROCERY STORE RECEIPT FROM 1997:

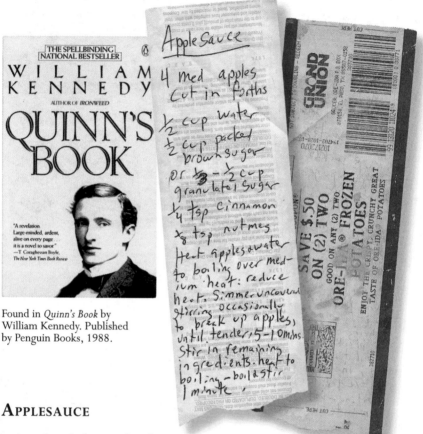

Found in *Quinn's Book* by William Kennedy. Published by Penguin Books, 1988.

APPLESAUCE

4 med apples, cut in fourths

½ cup water

½ cup packed brown sugar or ⅓–½ cup granulated sugar

¼ tsp cinnamon

⅛ tsp nutmeg

Heat apples & water to boiling over medium heat. Reduce heat. Simmer uncovered stirring occasionally to break up apples until tender, 5–10 mins.

Stir in remaining ingredients. Heat to boiling—boil & stir 1 minute.

Booby Trap

SEVEN RAZOR BLADES:

Found in *Stenciling with Style* by Jim Boleach. Published by Doubleday, 1985.

Beer Bread
3 c. self-rising flour
3 tbl sugar
1 can (12 oz) Beer Room temp.

Bake 1 hr 350°

Grease loaf pan
Brush top with Beaten Egg.

Biscuits
4 cup Jiffy Biscuit Mix
4 tbl sugar
1 can (13 oz) Beer Room temp.
Bake in muffin tins
oven 350°

Beer Bread and Biscuits

Beer Bread

3 c. self-rising flour
3 tbl sugar
1 can (12 oz) beer, room temp

Bake 1 hr 350°
Grease loaf pan
Brush top with beaten egg

Biscuits

4 cup Jiffy Biscuit Mix
4 tbl sugar
1 can (12 oz) beer, room temp

Bake in muffin tins
Oven 350°

Found in *James Bond and Moonraker* by
Christopher Wood. Published by Jove, 1979.

Dog Tags

TWO NEW YORK STATE DOG REGISTRATION TAGS, NUMBER 526834 FROM 1956 AND NUMBER 545849 FROM 1957:

Found in *The Winter of Our Discontent* by John Steinbeck. Published by Viking Press, 1961.

Ease-all

EASE-ALL BRAND METATARSAL
ELASTIC BAND SUPPORT, SIZE LARGE:

Found in *The Color Book of
Cakes and Cake Frostings*, edited
by Jo Barker. Published by
Octopus Books, 1978.

Emergency

A METAL SIGN; LOOKS LIKE ONE OF THE ONES YOU SEE ON SCHOOL BUSES:

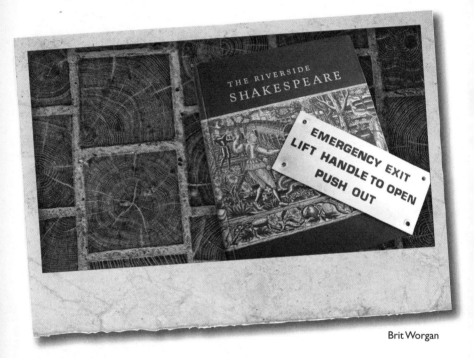

Brit Worgan

Found in *The Riverside Shakespeare*, edited by G. Blakemore Evans.
Published by Houghton Mifflin, 1974.

Night Shift Rules

A CARD GIVEN TO A CUSTOMER
UPON ENTRY OF AN ADULT NIGHTCLUB:

Night Shift Rules

B Y O B

Cans Only

No Bottled Beer

No Cameras

No Coolers

No Biker Attire

No Open Containers on
Parking Lot

You Are Not Allowed To Touch
The Dancers

If You Touch The Dancers You
Must Leave The Club!
No Refunds

Please Follow The Rules And
Enjoy Yourself And Come
Again Soon.

*If You Like The Club Tell Your
Friends, If Not Tell Us!*

(Over for Suggestions)

Found in *Totem and Taboo* by
Sigmund Freud. Published by
Vintage Books, 1946.

Dio

A CASSETTE TAPE INSERT FOR THE DIO ALBUM *INTERMISSION*:

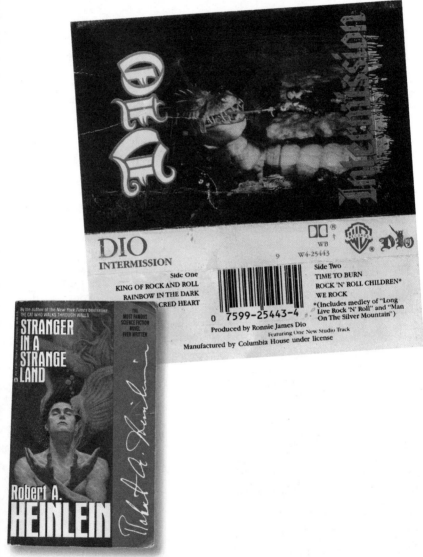

Found in *Stranger in a Strange Land* by
Robert A. Heinlein. Published by Ace Books, 1987.

Salem's Lot

A NEWSPAPER CLIPPING FROM
THE *BRIDGTON NEWS*,
DATED AUGUST 5, 1976:

Found in *Salem's Lot* by
Stephen King. Published
by Doubleday, 1975.

THE BRIDGTON NEWS

THURSDAY, AUGUST 5, 1976

"Salem's Lot" To Be Movie

The spooky vampire thriller, "Salem's Lot," written by Bridgton resident Stephen King, is now in the process of being made into a movie by Warner Bros. The hope is that it may match the appeal of previous shockers such as "Rosemary's Baby" and "The Exorcist."

King and his best-seller are also mentioned in the current (July 30) issue of Maine Times, as part of an article on the "Bookland" book stores operated by David Turitz of Portland News Company. Area residents will remember the eerie television ads which Bookland put on for "Salem's Lot" last fall.

Cold Beer

A PLASTIC STRIP ADVERTISING COLD BEER;
LOOKS TO HAVE COME FROM A LARGER SIGN:

COLD BEER

OVER TWO MILLION COPIES IN PRINT
SOUL on ICE
ELDRIDGE CLEAVER

Found in *Soul on Ice* by Eldridge Cleaver.
Published by Dell, 1970.

"Egyptian Dream Book," a small pamphlet on the interpretation of dreams. Published by Dr. V. M. Pierce, president of Invalids Hotel, Buffalo, New York.

The pamphlet is mostly an advertisement for the curative wonders of Dr. Pierce's impressive line of "family remedies":

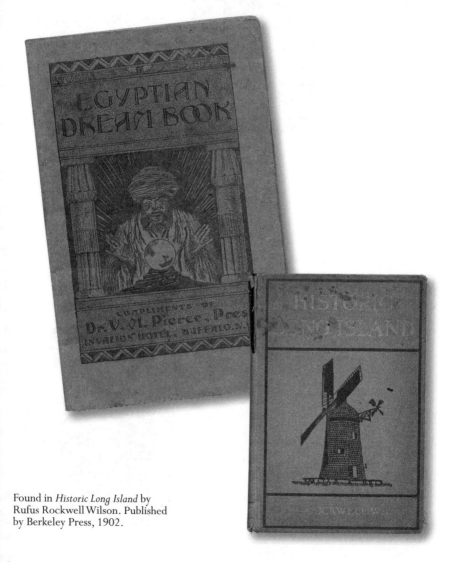

Found in *Historic Long Island* by Rufus Rockwell Wilson. Published by Berkeley Press, 1902.

Pee Wee

**A PEE WEE REESE
BASEBALL CARD,
1954 BOWMAN #58:**

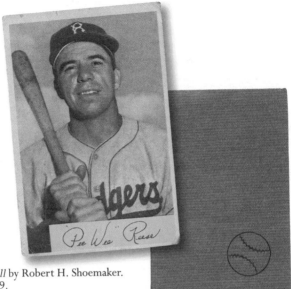

Found in *The Best in Baseball* by Robert H. Shoemaker.
Published by Crowell, 1959.

Carlton Fisk

A 1992 FLEER BASEBALL CARD FEATURING CATCHER CARLTON FISK:

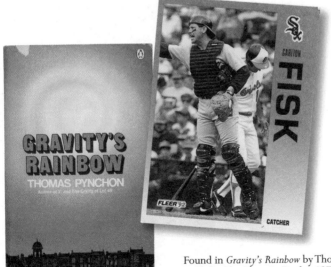

Found in *Gravity's Rainbow* by Thomas Pynchon.
Published by Penguin Books, 1973.

Salad Dressing

A RECIPE:

SALAD DRESSING

3 tablespoons butter
1 tablespoon flour
½ tablespoons salt
2 tablespoons sugar
1 teaspoon mustard
1 cup milk
1 cup vinegar
2 eggs

Beat butter and flour good. Add milk and let come to a boil. Mix salt, sugar and mustard, add eggs then vinegar and pour into boiling mixture and stir till thick.

Mrs. A. J. Healy

Found in *The International Cook Book*
by Margaret Weimer Heywood.
Published by Boston Merchandisers Inc.,
circa 1925.

Salad Dressing

3	tablespoons	Butter
1	"	Flour
1/2	"	Salt
2	"	Sugar
1	teaspoon	mustard
1	cup	milk
1/2	cup	vinegar
2	eggs	

Beat Butter and Flour
good. add milk and
let come to a boil
mix Salt Sugar and
mustard. add eggs
then vinegar and pour
into boiling mixture
and stir till thick

Mrs A. J. Healey

Universal Expo

A PLASTIC SOUVENIR BOOKMARK FROM THE UNIVERSAL EXPOSITION IN PARIS, 1900. FEATURES ADVERTISEMENTS FOR THE STANDARD MANUFACTURING COMPANY:

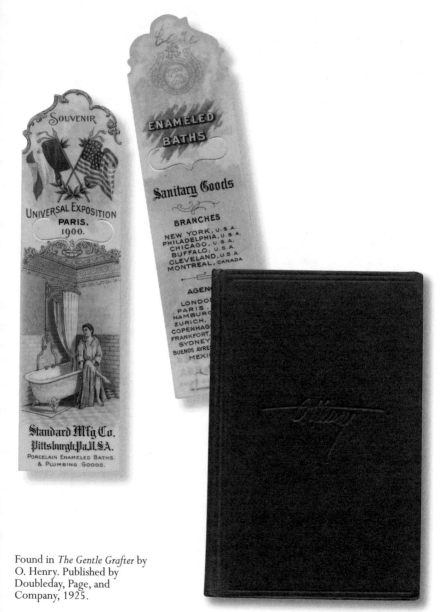

Found in *The Gentle Grafter* by O. Henry. Published by Doubleday, Page, and Company, 1925.

My Eyes Tired Here

A BOOKMARK:

> Lydia D. Dibble
> "My Eyes Tired Here"
> Compliments of your optometrist

ON THE BACK:

> "Here's Where I Fell Asleep"
> Compliments of Vision Conservation Institute, Inc.

Found in *Blood and Steel: The Rise of the House of Krupp* by Bernhard Menne. Published by Lee Furman Inc., 1938.

Fez

A CARDBOARD SHRINERS FEZ, SPECIFICALLY FROM
THE KALURAH TEMPLE IN ENDICOTT, NEW YORK:

Found in *Stories and Pictures: Floodtide in the Southern Tier.*
Published by R. E. Atwood, 1935.

Star Chart

A HANDWRITTEN STAR CHART DEMONSTRATING
POSITIVE AND NEGATIVE ASPECTS:

Found in *New Discoveries in American Quilts* by Robert Bishop.
Published by E. P. Dutton, 1975.

Fudge

A RECIPE FOR MRS. EISENHOWER'S FUDGE:

Mrs. Eisenhower's Fudge

4½ C. sugar
Salt (pinch)
2 T.B. Butter
1 can evaporated milk (tall)
 Bring to boil - boil
6 minutes.
 Put in bowl

12 oz. semi-sweet choc. bits
4 sq. bitter choc.
1 pt. marsh mallow cream
 (2 jars)
2 C. nut meats
 Pour boiling syrup
over choc. + cream, beat till

melted - pour in pan -

Mrs. Eisenhower's Fudge

 4½ c. sugar
 Salt (pinch)
 2 TB butter
 1 can evaporated milk (tall)

Bring to boil—boil 6 minutes
Put in bowl

 12 oz. semi-sweet choc. bits
 4 sq. bitter choc.
 1 pt. marshmallow cream (2 jars)
 2 c. nut meats

Pour boiling syrup over choc. and cream, beat till melted.
Pour in pan.

Found in *Bend Sinister* by Vladimir Nabokov.
Published by Time-Life Books, 1964.

SEVERAL DRIED AND PRESSED FOUR-LEAF CLOVERS:

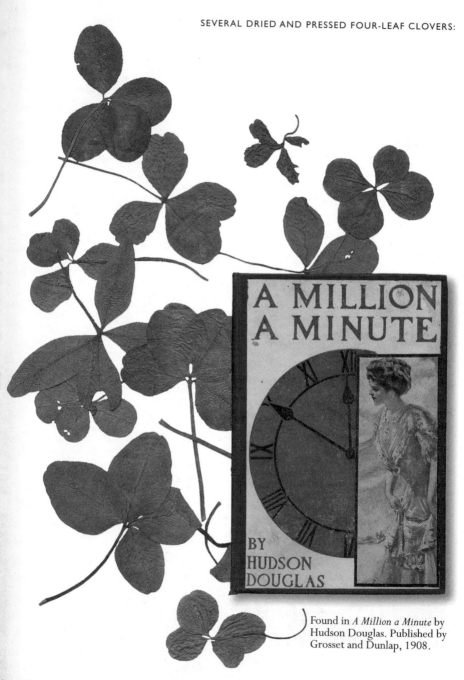

Found in *A Million a Minute* by Hudson Douglas. Published by Grosset and Dunlap, 1908.

Marshall Field

AN ILLUSTRATED ADVERTISEMENT:

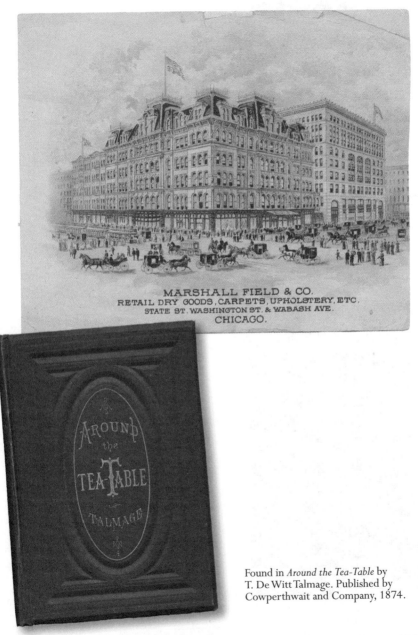

Found in *Around the Tea-Table* by
T. De Witt Talmage. Published by
Cowperthwait and Company, 1874.

A SMALL CARD FEATURING THE
SIX MILLION DOLLAR MAN:

THE REVERSE SIDE HAS A
"POWER" GRAPHIC:

Found in *After Things Fell Apart* by Ron Goulart.
Published by Ace Books, 1970.

Good vs. Evil

A DRAWING, IN PEN:

Found in *Relationship Rescue*
by Phillip C. McGraw, PhD.
Published by Hyperion, 2000.

Hairnet

A SENSATION BRAND HAIRNET,
MADE FROM NATURAL MEDIUM BROWN HUMAN HAIR:

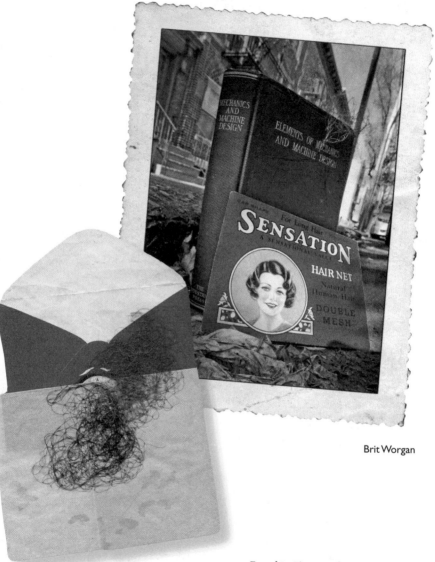

Brit Worgan

Found in *Elements of Mechanics and
Machine Design* by Erik Oberg.
Published by Industrial Press, 1923.

Mileage Rations

MILEAGE RATIONS AND AN ENVELOPE:

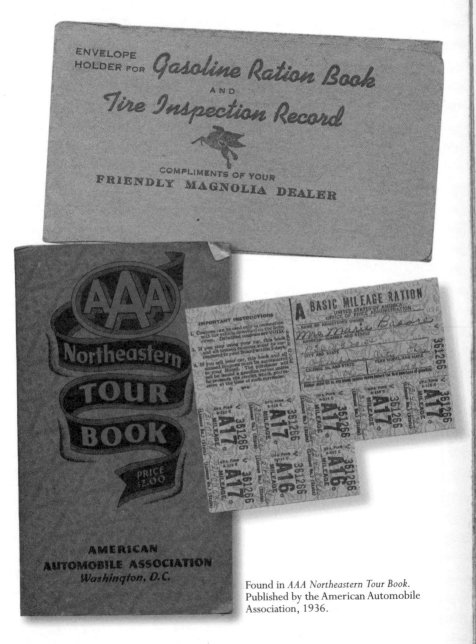

Found in *AAA Northeastern Tour Book*.
Published by the American Automobile
Association, 1936.

Mrs. Thom

A HOMEMADE NAME TAG WITH "MRS. THOM" WRITTEN ON THE FRONT:

A DRAWING OF A RABBIT ON THE BACK:

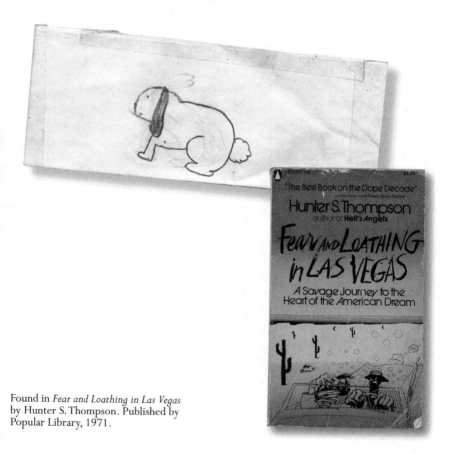

Found in *Fear and Loathing in Las Vegas* by Hunter S. Thompson. Published by Popular Library, 1971.

The Room

A COLORED-PENCIL SKETCH:

Found in *Mrs. Dalloway* by Virginia Woolf. Published by Harcourt Brace, 1997.

Peanut Butter Cookies

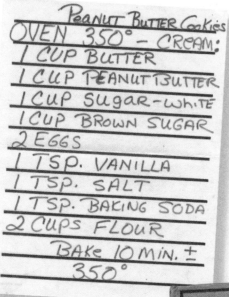

PEANUT BUTTER COOKIES

OVEN 350°—CREAM:

1 CUP BUTTER
1 CUP PEANUT BUTTER
1 CUP SUGAR—white
1 CUP BROWN SUGAR
2 EGGS
1 TSP. VANILLA
1 TSP. SALT
1 TSP. BAKING SODA
2 CUPS FLOUR

Bake 10 min +/−
350°

Found in *The Boston Cooking-School Cook Book* by Fannie Merritt Farmer. Published by Little, Brown, and Company, 1929.

Cap Gun Caps

A PACKAGE OF CAP GUN CAPS, UNUSED:

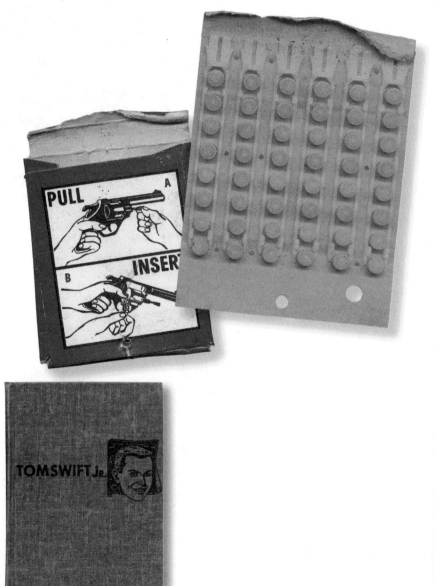

Found in *Tom Swift and His Rocket Ship* by Victor
Appleton II. Published by Grosset and Dunlap, 1954.

Phone Home

A DRAWING OF E.T., DATED AUGUST 24, 1982:

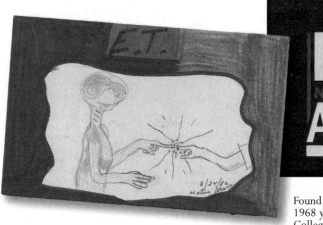

Found in *Fore 'n' Aft*, the 1968 yearbook for the College of St. Vincent.

Silence

A "DO NOT DISTURB" SIGN FROM THE HOTEL ASTOR:

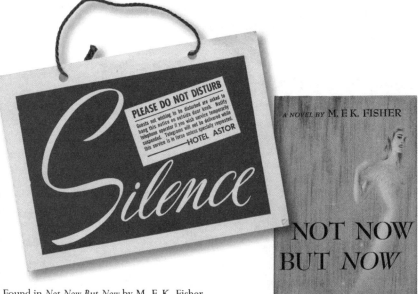

Found in *Not Now But Now* by M. F. K. Fisher. Published by Viking Press, 1947.

Sassafras

THREE DRIED AND PRESSED SASSAFRAS LEAVES, WITH A NOTE:

I hope these sassafras leaves arrive with even a portion of their peachy bronze color still evident—"one" of my favorite fall colors!

"E"

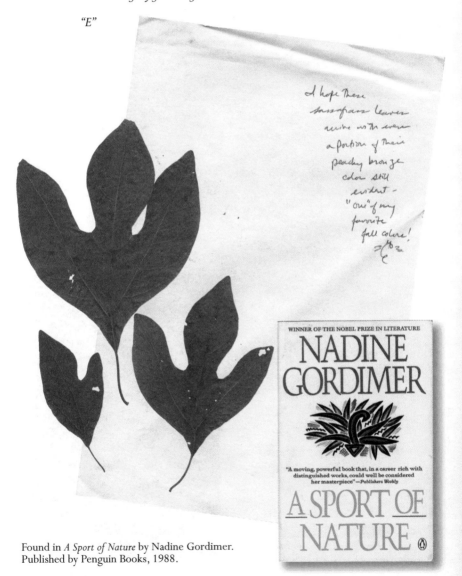

Found in *A Sport of Nature* by Nadine Gordimer.
Published by Penguin Books, 1988.

The Star-Spangled Banner

TWO SHEETS OF PAPER;
THE FIRST PAGE HAS A
LIST OF HANDWRITTEN
NAMES, SOME CROSSED
OUT IN RED PENCIL,
SOME CHECKED OFF. AT
THE TOP IS A BOLD RED
"BAD":

Found in *Building and Ruling the Republic*
by James P. Boyd. Published by Bradley
and Garretson, 1884.

THE REST OF THE TEXT
IS A TYPED COPY OF
"THE STAR-SPANGLED
BANNER," FOLLOWED
BY A HANDWRITTEN
VERSION:

Thanks

I'D LIKE TO offer a quick but heartfelt thanks to my parents, the people who made the blog and this book possible. Needless to say, there would be no forgotten bookmarks without the books. I would also like to give my unending gratitude to my wife, Emily; it was her constant support and encouragement that kept me plugging away. All I ask is that this book makes her proud.

My agent, Kate McKean, deserves a hearty thank-you for guiding me through this process. I felt like she understood what *Forgotten Bookmarks* was all about from the beginning, and I hope this publishing novice wasn't too much of an annoyance. I would also like to thank Maria Gagliano simply for giving me a chance.

One of the more difficult chores of the blog is trying to decipher the scrawling, aged, faded, and awful handwriting found in many of these old notes and letters. My thanks go to Sara Anderson for helping make some sense of the scribbles.

Finally, in no order of importance, I would like to thank Alex Belth, David Bowie, Deidre Willies, Emma Span, Hannah Elliott, William Shatner, Adrienne Martini, and everyone who has left something behind in a book.